NORTH BY NORTHEAST

WABANAKI, AKWESASNE MOHAWK, AND TUSCARORA TRADITIONAL ARTS

KATHLEEN MUNDELL

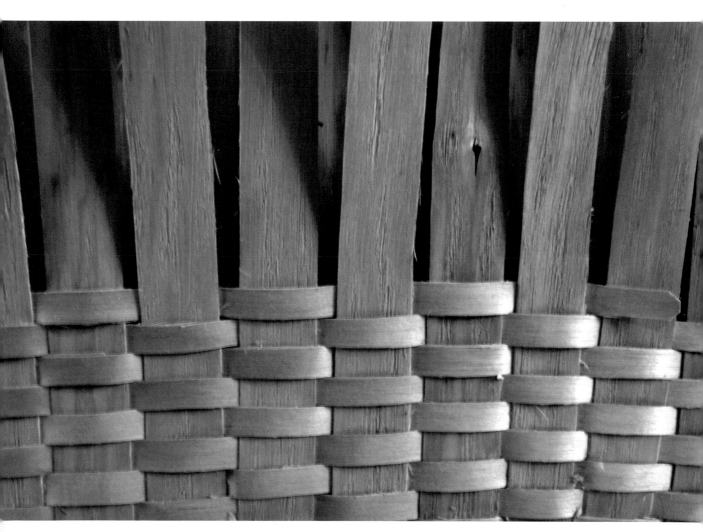

Essays by Salli Benedict, Sue Ellen Herne, Jennifer Neptune,
Theresa Secord, and Lynne Williamson

Tilbury House, Publishers • Gardiner, Maine

TILBURY HOUSE, PUBLISHERS
103 Brunswick Avenue
Gardiner, Maine 04345
800–582–1899 • www.tilburyhouse.com

First paperback edition: August 2008
10 9 8 7 6 5 4 3 2 1

Library of Congress Cataloging-in-Publication Data
North by northeast : Wabanaki, Akwesasne Mohawk, and Tuscarora traditional arts / Kathleen Mundell with essays by Salli Benedict ... [et al.]. — 1st paperback ed.
 p. cm.
 Includes bibliographical references and index.
 ISBN 978-0-88448-305-2 (pbk. : alk. paper)
 1. Abenaki art. 2. Tuscarora art. 3. Indian art—Northeastern States. I. Mundell, Kathleen.
 E99.A13N67 2008
 709′.01′1—dc22
 2008014359

Cover: Ash and sweetgrass basket by Sheila Ransom (Mohawk), photographed by Peter Dembski
Title page: Utility basket by Richard David, photographed by Peter Dembski
Designed by Geraldine Millham, Westport, Massachusetts
Copyediting: Genie Dailey, Fine Points Editorial Services, Jefferson, Maine
Printed and bound by Sung In Printing, South Korea

ACKNOWLEDGMENTS

As part of a traveling exhibition that will tour the Northeast begining in 2008, *North by Northeast: Wabanaki, Akwesasne Mohawk, and Tuscarora Traditional Arts* was generously supported by funding from the National Endowment for the Arts, Folk and Traditional Arts Program; the Wyeth Foundation for American Art; and the Smithsonian Institution, National Museum of the American Indian, Visual and Expressive Arts Grants program. Their support is most appreciated.

I would also like to thank all the talented artists who participated in *North by Northeast;* the staff of Tilbury House, Publishers; Salli Benedict, Sue Ellen Herne, Theresa Secord and Lynne Williamson for their advice; my supportive family: Margaret, Julian, Karen, Michael, and Emily; and a special thank-you to Peter Dembski for all his help, patience, and good humor.

Kathleen Mundell

Beaded hummingbird by Niio Perkins, photo by Roger Harmon

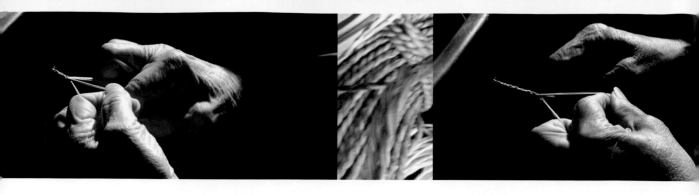

INTRODUCTION

North by Northeast is based on the words, work, and images of practicing
Wabanaki and Haudenosaunee artists. It offers a window into traditional arts
as they are practiced in three communities in the northeast corner of the
United States: the Wabanaki of Maine (Maliseet, Micmac, Passamaquoddy,
and Penobscot tribes) and two of the six Haudenosaunee nations: the
Mohawks at Akwesasne in the St. Lawrence River Valley and the Tuscarora
at the Tuscarora Reservation in Niagara Falls, New York.

Carrying on long-standing community traditions like basketry
and beadwork, the artists featured in *North by Northeast* create work based
on tribal and familial connections and an ever-present tie to the landscape.
Collectively, their work represents some of the oldest, most viable traditional
arts practiced in the region today.

North by Northeast developed after many years of conversations
with traditional Native artists. One such conversation was with Madeline
Shay, a respected elder, master basketmaker, and Penobscot speaker on Indian
Island, Maine. In 1990 I went to visit Madeline to see if she was interested
in teaching in the Maine Arts Commission's newly established apprenticeship
program. One of the few basketmakers still practicing her art, Madeline
was deeply concerned about its future. Although she liked the idea of the
apprenticeship program, she had other concerns—dwindling supplies of ash,
low basket prices, and difficulty in finding younger, interested students.
She taught me that you can't separate the art from the place, the materials,
or the tradition; all are inextricably linked. Madeline Shay also introduced
me to Theresa Secord, a Penobscot basketmaker and geologist. These early
conversations and meetings helped shape things to come: a successful ongoing
apprenticeship program and the eventual creation of the Maine Indian
Basketmakers Alliance.

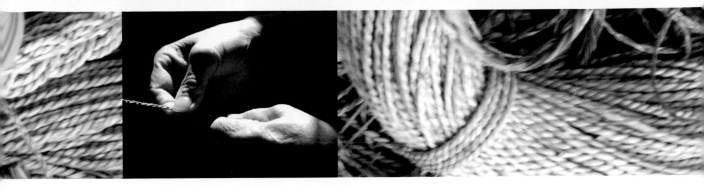

Twelve years later, I was invited by the New York Folklore Society to visit with a group of Akwesasne basketmakers and Tuscarora beadworkers in New York State. Many of these artists were facing the same issues: difficulties in finding natural materials and new markets, and not enough recognition of the importance of their work outside of their own communities. Yet despite these problems, their traditions remain vibrant.

As a folklorist, I've always been interested in hearing what artists and community members have to say, and in bringing these different perspectives to a larger audience. *North by Northeast* is written in this collaborative spirit. I am very grateful for the contributions of Salli Benedict, Sue Ellen Herne, Jennifer Neptune, Theresa Secord, and Lynne Williamson, and for the images of photographers Darel Bridges, Cedric Chatterley, Peter Dembski, Jere DeWaters, Roger Harmon, Peggy McKenna, and Martin Neptune.

North by Northeast is part of an exhibition that will travel to the Akwesasne Museum and Cultural Center, the Abbe Museum in Bar Harbor, Maine, and the Pequot Museum in Mashantucket, Connecticut, throughout 2008 and 2009. It builds on the ongoing work of the Akwesasne Museum, the Maine Indian Basketmakers Alliance, Cultural Resources, the Maine Arts Commission, the Castellani Art Museum of Niagara University, TAUNY, the New York Folklore Society, and the New York State Council on the Arts, Folk Arts Program in supporting the work of traditional artists in the region.

Kathleen Mundell
Cultural Resources

Florence Benedict braiding sweetgrass, photo © Peter Dembski
Detail of Judy Cole's sweetgrass, photo © Peter Dembski

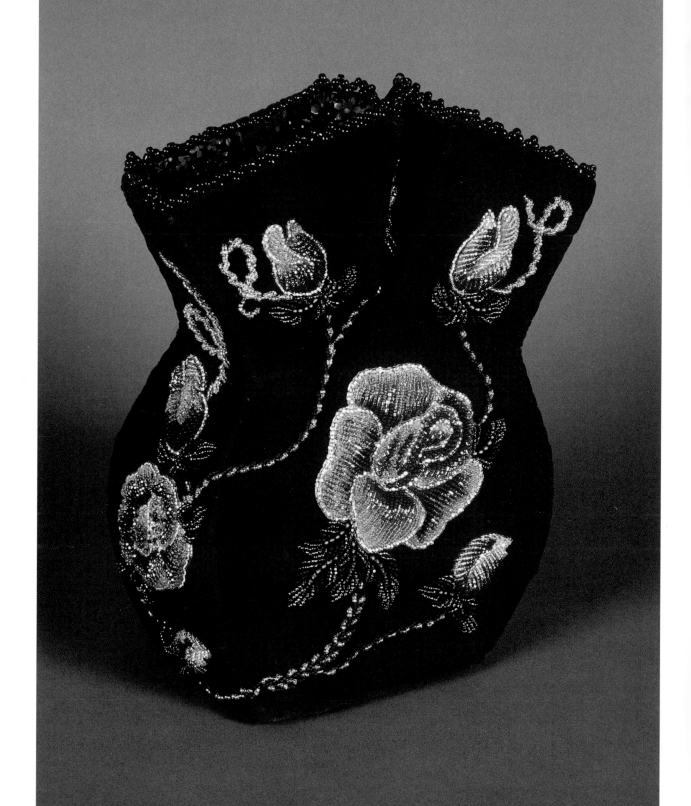

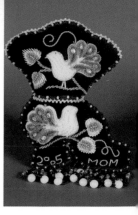

HAUDENOSAUNEE TRADITIONAL ARTS: A GLIMPSE INTO OUR HOUSE
Sue Ellen Herne (Mohawk) and Lynne Williamson (Mohawk heritage)

One translation of the word *Haudenosaunee* is "People Building a House." The sky is the roof, the earth is the floor, the Mohawk Nation is the eastern door, and the Seneca nation is the western door of our house. The Haudenosaunee, also known as the Six Nations Iroquois Confederacy, are the Mohawk, Oneida, Onondaga, Cayuga, Seneca, and Tuscarora. We have been taught that the spiritual, political, social, and cultural organizations of our people reside within this house. Traditional teachings, stories, songs, symbols, language—all of these shared understandings—tell us who we are as Haudenosaunee. Our traditional arts continue to be visible and tangible expressions of a cultural home that our neighbors and we still recognize as our own. Deeply rooted in our experience of place, traditional arts encourage cooperation, nurture community-wide ties, provide us with things we use on a daily basis, and connect us to the knowledge and customs of our ancestors.

Traditional art forms found in our house today include beadwork, basketry, stone and wood carving, cornhusk doll making, pottery, lacrosse stick making, and the sewing of traditional clothing and quilts. Two of the most widely practiced art forms, beadwork from Tuscarora and basket making from Akwesasne, have been done for generations, and still attract many new artists who are learning and extending these traditions. In both communities, traditional artists have traveled to museums and private collections to study the older forms of beadwork and basketry, often recognizing pieces made by their elders, and classes are helping to develop a whole new generation of skilled artists in these traditions. We cherish the connection to our ancestors and embrace the creativity that adds new ideas to our long-standing art forms. Each basketmaker, each beadworker, also brings a personal touch and signature style to the tradition.

Located where New York State, Ontario, and Quebec intersect, the Mohawk community of Akwesasne (Land Where the Partridge Drums) exemplifies the many ways in which traditional arts play a vital role in

Beaded boot by Rosemary Hill (Tuscarora), photo © Peggy McKenna

Opposite page: Beaded vase by Dolly Printup Winden (Tuscarora) photo © Peggy McKenna

1

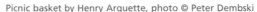
Mohawk basketmaker Henry Arquette, photo © Peter Dembski
Picnic basket by Henry Arquette, photo © Peter Dembski

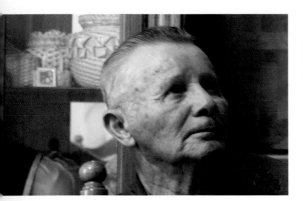
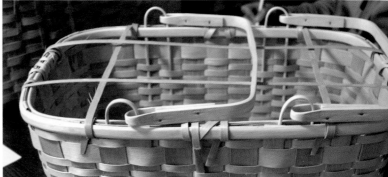

Haudenosaunee life. Despite rapid change, particularly over the recent decades, Akwesasne remains a vibrant place that holds its heritage close to heart, while not fearing innovation. New businesses have multiplied and, yes, a casino and bingo are part of the landscape, but cultural conservation remains a top priority. Our deeply held respect for the environment encourages participation in traditional ways of life, and stimulates us to become involved in advocacy, education, and environmentally related careers. Akwesasne is known as the Haudenosaunee community with the strongest continuous tradition of basket making. More than a utilitarian craft, basket making is a cultural process, a way of learning about the cycles of nature and the right way to live in balance with the land by gathering materials carefully. Basket making connects us deeply to the ecology of Akwesasne, and one example of our environmental work in recent years has been a long-term restoration project for black ash trees, the most important source for basket-making splint.

Black ash splint and sweetgrass baskets are made for regular use in Akwesasne Mohawk homes, for ceremonies, and as a source of income. Although basketry has declined in many Haudenosaunee communities, it continues as one of Akwesasne's strengths, despite a scarcity of black ash trees and a tenuous market. Some of the oldest basket styles, such as corn-washers, have been made and used for centuries. Henry Arquette, the finest

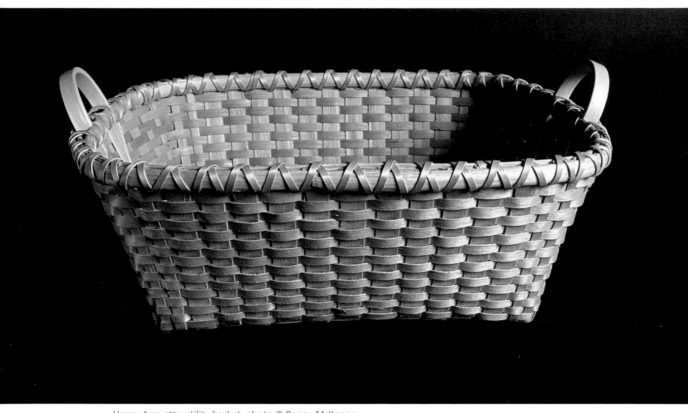

Henry Arquette utility basket, photo © Peggy McKenna

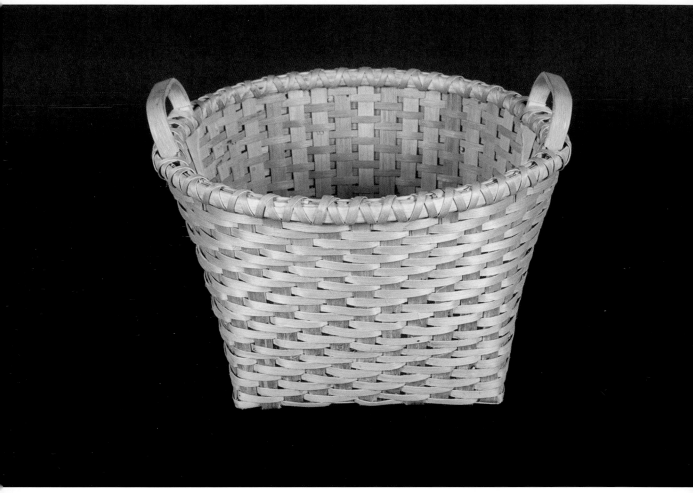

Corn-washer basket by Henry Arquette, photo © Peggy McKenna

work-basket maker in Akwesasne today, is well known across the Northeast. His *ienon'stohare'takhwa* (corn-washer baskets) can be appreciated for their aesthetic value alone, but many people in Akwesasne use them for the traditional task of washing white corn. White corn is grown across Haudenosaunee territory for use in *onàntara* (soup) and *kanótaron* (bread). Once the long white ears of corn are harvested, shucked, dried, and shelled, they are boiled in water with hardwood ashes to release the hard, indigestible hulls. After the kernels are separated from the hulls, they need to be rinsed in water to clean off the ashes. The texture of the corn-washing basket's twill weave helps to loosen any errant hulls from the kernels, and the wide spacing of the bottom allows the water and ash to freely flow out.

Basketry involves symbolism as well as practicality and utility. The sky-dome motif seen often in beadwork features half circles resting atop intricate border lines, signifying the sky of our natural world and the sky-world above from which this world was created. During social and ceremonial gatherings today, we wear these symbols on our clothing as reminders of our worldview. Sky domes are also part of the rim of some baskets, where alternating-sized domes are interwoven as reminders of each generation's experience in the world. Unique basket styles that have been created in recent years include Mary Adams's Wedding Cake and Pope baskets, and Florence Benedict's Globe Basket, an art piece woven with many yards of braided sweetgrass, a time-consuming labor of love. Florence's daughter,

Beadwork by Niio Perkins referencing sky-dome motif, photos by Roger Harmon

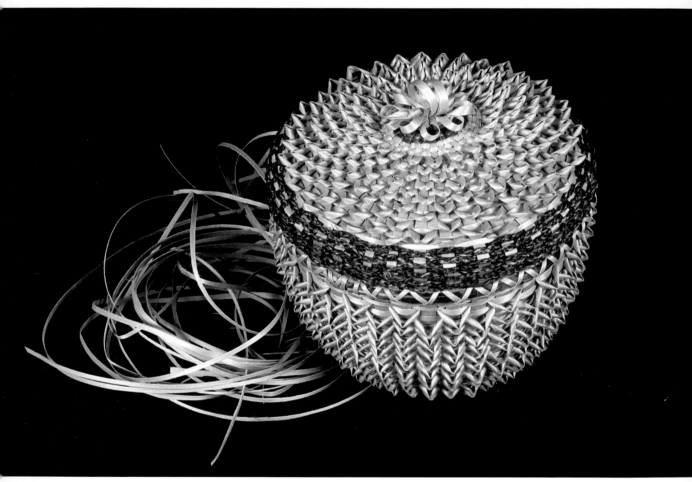

Popcorn basket by Linda Jackson, photo © Peggy McKenna

artist, curator, and writer Salli Kawennotakie Benedict, explains the meaning of sweetgrass this way: "In Rotinonshonni [Haudenosaunee] culture, sweetgrass is the 'Hair of Mother Earth.' Its sweet fragrance is appealing and endears us to her. We know that we are not disconnected from our Mother Earth when we can smell her sweet hair."

It has long been part of the fabric of Haudenosaunee life for families to practice traditions in collaboration. In Akwesasne, the entire community participates in basket making, as it may be a person outside of the extended family who harvests the logs and pounds them into splint, or who crafts the basket molds and tools. The involvement of the broader community may be even more pronounced today than in past generations when the pounder was most likely to be the man of the family and the children assisted in the basic stages of basket making.

From the late 1800s to the mid-twentieth century, large quantities of baskets were sold by non-Native storekeepers for a few cents a dozen, and the pay to the basketmaker was even less—usually credit vouchers to be used in the store. Through the work of many advocates in the art and folklife worlds, today's prices better reflect the long hours, skill, and artistic excellence of our basketry tradition, but the market is uneven at best. Few can use basket making as their main income, but many Akwesasne Mohawks excel in both art and business well enough to supplement their income and keep the tradition vigorous. The love of this art form and its ties across the community and beyond keep our basketmakers' spirits strong.

The knowledge of basket making has been passed down in families for generations. In the 1970s the Akwesasne Museum began holding classes to ensure that the tradition would continue, filling the gap created in modern times when parents need to take jobs outside of the home rather than living off the land and pursuing basketry as part of family based livelihoods. Skilled basketmakers have been teaching Mohawk community members in an informal classroom setting at the museum, as well as in recreation halls and

other cultural venues. Most of the instructors are fluent in the Mohawk language. We feel the love of our ancestors, our nations, our clans, and our families when we hear the language and its use in our oral tradition. It is a powerful factor in traditional arts retention to pass on the specific terms related to an art's objects, processes, and components. That is best done when both teacher and student are fluent speakers, but it is also empowering for people with limited language knowledge to hear the language while learning basketry skills.

Just as cultural knowledge is embedded in language, the Haudenosaunee worldview is incorporated into our beadwork patterns, such as the sky dome, the strawberry, the six-petal flower, and clan animals—all symbols from our oral tradition. The distinctive Haudenosaunee form of "raised beadwork" features a layering of beads on a velvet background, creating a textural effect. Beadwork designs portray Haudenosaunee cultural events from the Creation to the formation of the confederacy, and also include iconic imagery such as American flags, or place names such as Niagara Falls on tourist souvenir pieces. Many Haudenosaunee artists made beadwork, with Tuscarora as the most widely known and prolific community producer—perhaps because of its proximity to Niagara Falls, a major site for sales of beadwork to tourists. Kahnawake, located near Montreal, has continued the beadwork tradition to the greatest extent of any Mohawk community, and young artists in Akwesasne are also making some exciting beadwork today.

Haudenosaunee artists and tradition bearers share ideas, designs, techniques, materials, and knowledge as we create our work. Our communities remain close-knit and traditional, but we also move beyond the boundaries of geography, time, and style in our art. We have given a glimpse into some of the beloved and vibrant traditional arts made in our house. Keep in touch with us as the story continues!

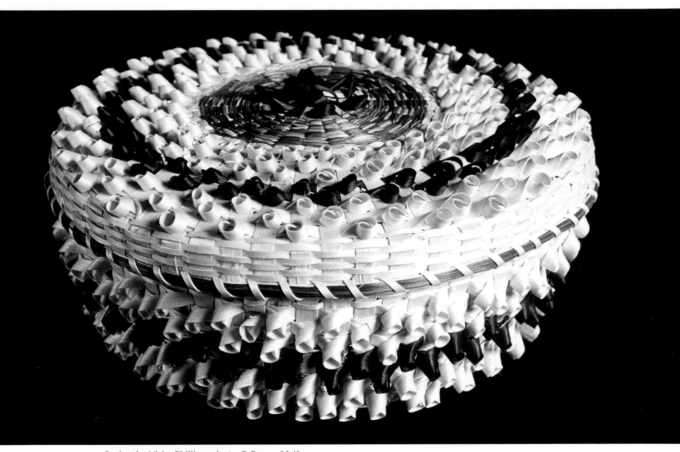

Basket by Vicky Phillips, photo © Peggy McKenna

Basket by Sheila Ransom, photo © Peter Dembski

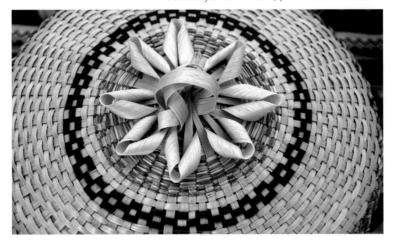

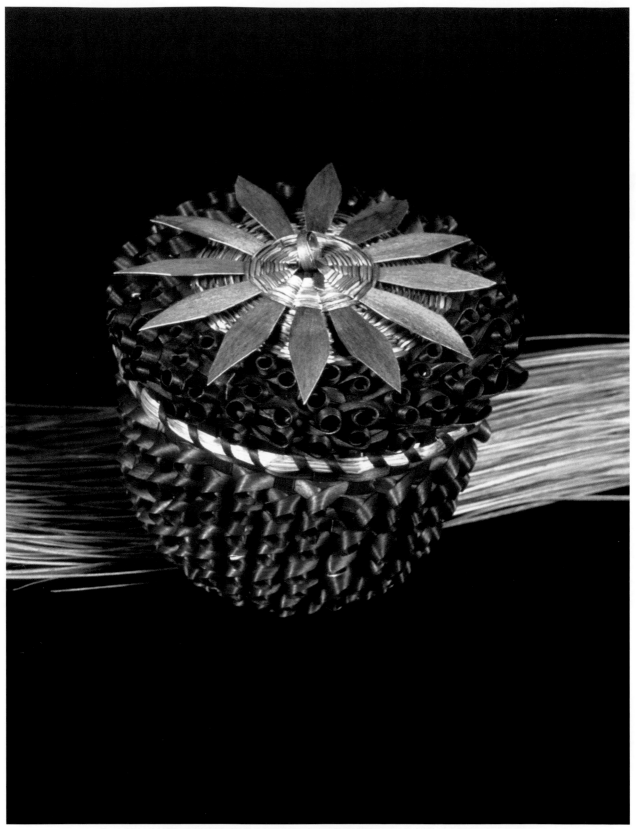

Strawberry basket by Annabelle Oakes, photo © Peggy McKenna

AKWESASNE BASKET MAKING: AN ENDURING TRADITION
Salli Benedict (Mohawk)

It's an old question that people have asked Akwesasronon, and that is, "What does the art form of Akwesasne basket making mean to its people?" One answer that was provided by an Akwesasne elder is that "it brings us together." Basket making brings Akwesasne people together to gather natural products that are used to make the baskets. When we gather to make baskets, we speak our language, share our culture, tell stories of the past, and share ideas for the future.

More than all that, basket making brings us together with all elements of our natural world—from the People to the Creator—and ensures our connection to them. Basket making may seem like a simple art form to some people, but it ensures our continued engagement with the land and our environment, and that connection is the foundation of our culture.

OHENTEN KARIWATEKWEN (WORDS BEFORE ALL ELSE)
At gatherings, Haudenosaunee people begin by delivering an opening address that offers thanksgiving to all the elements of Creation. It begins with gratitude for the People, and extends to Mother Earth, the Waters, the Fish, the Plants, the Animals, the Trees, the Birds, the Four Winds, the Thunderers, the Sun, the Moon, the Stars, the Sacred Beings, and the Creator.

All of the elements mentioned here are essential for our own survival and for the survival of our cultural traditions, including Akwesasne Mohawk basketry.

REMEMBERING OUR RELATIONSHIP WITH THE NATURAL WORLD
Akwesasronon use basket forms to acknowledge our respect for various elements of Creation and the natural world. For example, the strawberry basket is made to remind us of our Creation Story and the Sky Woman who fell to Earth, bringing sacred tobacco and strawberries with her to this new environment. Each time we see the strawberry basket we are reminded of this special plant that provides nourishment and medicine to us in the late spring. We show our gratitude in a traditional ceremony that is held each year.

Florence Benedict preparing sweetgrass with her granddaughter, photo by Rebecca Benedict

Katsiskaienitoton means "shell," and it is a special weave in baskets that reminds us of our relationship to water creatures and of the special use that we have had for shells. Among the Haudenosaunee and other indigenous people, shells such as wampum have helped us record important relationships between nations where agreements and covenants needed to be remembered.

Kanionwarote means "thistle" and is another of the special weaves that we use in Akwesasne baskets. This weave not only relates our gratitude for the thistle as an important fiber for cordage, or as a medicine plant, but also for the symbolism that it holds with regard to our form of governance.

Kakonsha means "faces." This weave reminds us of the "coming faces," or upcoming generations, for which we are responsible. It also reminds us to give careful consideration to the decisions we make today because they will have an impact on the coming faces. The "faces" weave is sometimes interpreted as a kernel of corn, which is a very important symbol in Haudenosaunee culture.

There are other weaves and embellishments that are used in Akwesasne basketry. One lacy scalloped edge reminds us of the sky dome or the mounds of earth in which we plant corn, beans, and squash. What is important about all these representations is that they are helpful reminders for us about our relationship with our environment. These subtle reaffirmations are reflected in our basketry designs and patterns and help to keep our vital connection to the natural world.

SACRED CULTURAL TRUST RESPONSIBILITY

At Akwesasne we have known for some time that Kanienkeha (our Mohawk language), our traditional arts, our traditional practices, and our weaving traditions all have a fragile existence. Each generation has a tremendous responsibility to ensure the survival of the various components of our culture. This responsibility is not taken lightly. Some call it a sacred cultural trust responsibility, and we count on each generation to honor that responsibility.

Opposite page: Thistle basket by Florence Benedict, photo © Peter Dembski

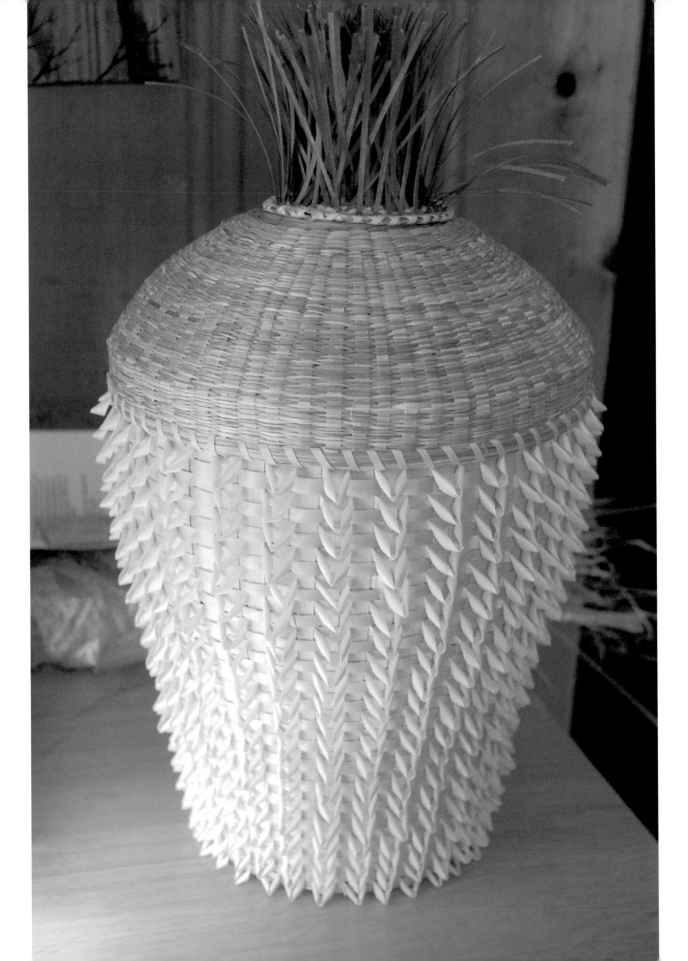

Many times this responsibility falls to the women, who have everyday inter-action with the children. Sometimes women take in others and show them how to live responsibly and respectfully within our world.

Luckily, we have those in our community today who are here to remind us of our responsibilities to the survival of our culture. The respon-sibilities upon the current generation are tremendous given the myriad of outside influences that work to diminish the importance of our own culture.

We owe a great debt to all those Akwesasronon that have insisted on the survival of our Mohawk culture and have worked hard to ensure its con-tinuation from generation to generation. We are grateful that Akwesasronon have chosen basketry as one of the elements of our culture that must continue.

NEW NESTS WITHIN THE AKWESASNE COMMUNITY

While basketry it is still taught in many Akwesasne family homes, the home environment has changed in these modern times and not every home is a convenient place for basket making to thrive. Fortunately, Akwesasne basketry has found new environments within the community from which to grow. Schools and cultural centers, and even places outside of our community, have provided wonderful settings for perpetuating this art form.

Greatly assisting the survival of Akwesasne basket making, the Akwesasne Museum and the Native North American Traveling College–Ronathahonni Cultural Center have played an essential role. Additionally, they have provided space and instruction that has been utilized by our people for more than thirty years.

CLOSING WORDS OF ACKNOWLEDGMENT

Our acknowledgment of Akwesasne Mohawk basketmakers is vital. They are people who have kept many Akwesasne Mohawk cultural traditions alive, including basket making, for generations. They are the ones who built nests where this cultural art could thrive. Utilizing sweetgrass and black ash splint as the preferred local and traditional materials, Akwesasne men and women have excelled at producing a style of Mohawk basketry that is unique to this St. Lawrence River Valley area.

We note the passing of some of the master Akwesasne basketmakers who had dedicated their lives to the perpetuation of this ancient art form. We acknowledge their work as master weavers and as teachers and mentors of the art. We recognize the loss of traditional cultural knowledge that has been taken with each of these special people, and we hope that we honor their memories by working diligently to carry on the basketmaking tradition that was their hallmark. We acknowledge their legacy to the current generation, who now carry the responsibility of passing on this artistic expression of our culture to the future.

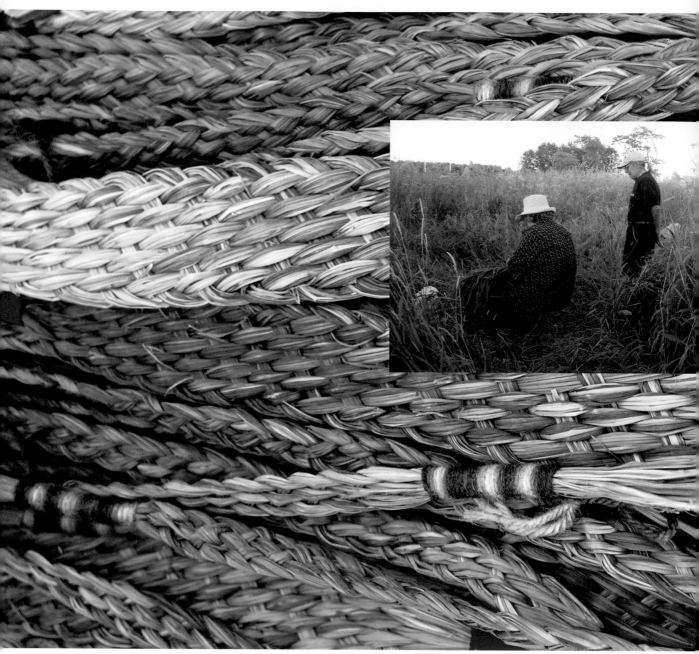

Insert: Florence and Ernest Benedict gathering sweetgrass, photo by Salli Benedict
Sweetgrass braids, photo © Peter Dembski

Onenhakenhra: White Corn Basket by Florence Benedict, photo by Salli Benedict

THE GLOBE BASKET SERIES OF AKWESASNE BASKETMAKER FLORENCE BENEDICT (KATSITSIENHAWI)

Salli Benedict (Mohawk)

Florence Benedict (Katsitsienhawi, "She carries flowers") is a Mohawk of Akwesasne. She resides on Kawehnoke Island with her husband of fifty-six years, Ernest Benedict (Kaientaronkwen, "He gathers the small sticks of wood as in ceremonial game"), in a century-old farmhouse overlooking the magnificent St. Lawrence River. Her children have built homes nearby, and daily visits are made by children, grandchildren, and great-grandchildren to "Tota and Tota-man's" house. (Tota is a contraction of Ahksohtha/Grandmother and Rahksohtha/Grandfather.)

Katsitsienhawi, as she is known to her family members, has made baskets her whole life. Taught by her maternal grandmother, Cecelia Thompson (Kaiatahente, "She is in front"), Katsitsienhawi also received instruction from her mother, Cecelia (Sarah) Lefebvre-Thompson Hopps (Kahentineshen, "Hills and strawberry fields for as far as you can see"), and other maternal relatives such as Christie Thompson Jacobs (Kiohontasen, "Sweetgrass is around her") and Josephine Delormier (Kanatahawi, "She brings the encampment or village"), all of whom have contributed to the transmission of this cultural art form to her generation. In turn, Katsitsienhawi has passed the knowledge to her children and grandchildren, who continue to develop their skills in Akwesasne Mohawk basketry.

Katsitsienhawi picks the sweetgrass for her baskets every summer during the months of July and August, collecting enough to last for the coming year. She is often accompanied by her husband, daughter Rebecca Benedict (Wenniseriiostha, "She makes the day nice"), sisters, or others who wish to help in the process. Black ash splints are provided by Akwesasne neighbors who specialize in selecting the trees that are cut and "pounded" to make the splints available to Akwesasne's basketmakers.

Katsitsienhawi makes baskets year-round. She is also an avid quilt maker. In the summers, she makes time to prepare and tend to her vegetable garden and to teach children who have an interest in pursuing basket making through summer classes provided by the Akwesasne Museum. Her sister

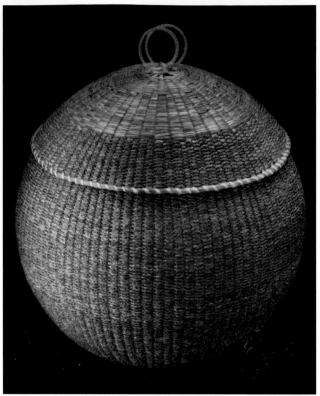

Hair of Mother Earth Basket by Florence Benedict, photo courtesy of Farmer Museum, Cooperstown, NY

team-teaches with her at the museum, and both enjoy sharing these ancient skills with a new generation of Akwesasronon.

THE GLOBE BASKET SERIES

Florence Benedict (Katsitsienhawi) has designed a series of large, round sweetgrass-and-black-ash baskets that she calls "Globe Baskets." This reference is made because they represent Mother Earth or the World. Each Globe Basket has a specific story to tell that reminds us of special relationships and obligations that we have to our Mother the Earth.

HAIR OF MOTHER EARTH BASKET

Sweetgrass is the hair of Mother Earth. The Hair of Mother Earth Basket was the first in the Globe Basket series. For the Hair of Mother Earth Basket, individual strands of sweetgrass are braided and then woven between the spokes of hand-pounded black ash wood-splint.

Friendship, Peace, and Respect by Florence Benedict, photo by Rebecca Benedict

Friendship, Peace, and Respect Basket

The sweetgrass used in this basket is collected from areas in the Adirondacks that have been used by our people for generations and continue to be part of our aboriginal territory. Numerous place names within the Adirondacks still hold Mohawk names that were given to those special locations by our ancestors generations ago and illustrate our dependence on the natural resources of the region.

Katsitsienhawi carefully braids the individual strands of sweetgrass that she has picked and prepared, and then weaves the braided grass between the spokes of black ash splint that have also been harvested from our Adirondack lands. This basket has special meaning for us in this day and age when the Earth Mother herself struggles for survival. This concern alone should unite all people to come to the aid of Mother Earth. We all share the resources of the Earth. It is the duty of all people of the Earth to adopt philosophies and establish ways that are respectful of the Earth and will allow the continued existence of all elements of Creation, from the smallest to the largest and to all the forces of the natural world.

There is a motif around the equator of the basket, reminiscent of Haudenosaunee (Iroquois) wampum belts that are made especially when a friendship or relationship needs to be established for the mutual well-being of the parties. In this configuration, a continuous chain of people are linked together around the basket, symbolically united in their commitment to preserve this Earth we share.

On the top of the basket is a sweetgrass braid, presented as an offering to the Creator. The braid is linked to our good thoughts, which are represented in the three purple rings joining Peace, Friendship, and Respect together. It is our hope that similar values will bring us together for the preservation of the planet.

Striped Gourd Basket by Florence Benedict, Rebecca Benedict, and Luz Benedict, photo by Rebecca Benedict

STRIPED GOURD BASKET

The gourd is a primary member of the squash or pumpkin family. Squash is one of the essential food staples among the Haudenosaunee nations that are known as Kionhekkwa, or "Life Givers." We have three special Life Givers which we consider to be related to each other. They are corn, bean, and squash, and we refer to them as the "Three Sisters." Corn, bean, and squash, in their many varieties, have myriad uses for us beyond their food value, and we have depended upon these wonderful plants to fulfill everyday needs, emotionally, physically, and spiritually.

The striped gourd is not one of the edible members of the squash family, but it is still essential as a container for holding our food or water, or for supporting our fishing nets. The gourds are also useful to us in making music, so that we can sing the songs that are our thanksgiving tribute to the Creator and all elements of Creation. We believe that as long as we are thankful and respectful of the gifts of the Creator, the World will have the resources we need to survive. Everybody sing!

ONENHAKENHRA: WHITE CORN BASKET

White corn is one of the Three Sisters that are the staples of the Haudenosaunee. This basket is made to acknowledge the eldest sister and the oldest variety of corn, which we know as Onenhakenhra. Corn is considered to be the seed of democracy. Because we had the corn, we were able to build a culture that could work with and around the corn. This meant that we could spend more time in one place, that we could make long-range plans, and that we could depend on the corn for our survival. With the corn, we could also recognize the contributions of both men and women to our culture and way of life, and thus give them each special responsibilities within our governing structure.

Corn has always been an important element of Haudenosaunee culture. It has also been important to most other indigenous cultures of the Americas and around the world. This basket gives recognition to the importance of corn on a global stage.

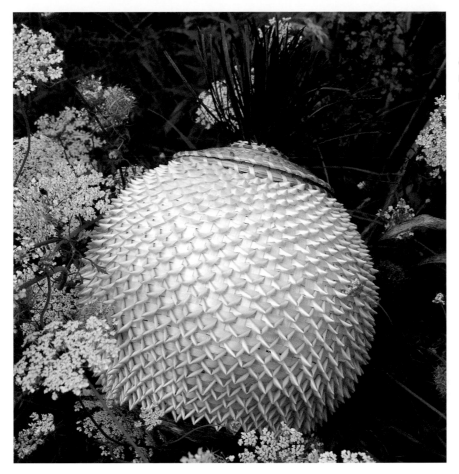

Globe Thistle Basket
by Florence Benedict,
photo by Salli Benedict

GLOBE THISTLE BASKET

An elder statesman and Rotinonkwiseres ("Long Hair," meaning traditional life chief) within the Akwesasne community, Ernest Benedict (Kaientaronkwen), husband of Katsitsienhawi, often recites what he knows as the Preamble to the Kaianerakowa or the Constitution of the Haudenosaunee Confederacy.

He remembers it thus: "In the shade of the Great Tree of Peace, we spread the soft white feathery down of the Great Globe Thistle as seats for you, Tadadaho, and your cousin lords. There shall you sit and watch the council fire of the Five Nations [the Iroquois Confederacy]. Roots have grown out from the Great Tree of Peace—one to the east, one to the north, one to the south, and one to the west—and they shall encircle the Earth, so that all people may trace these roots to their source and shall be welcome to take shelter beneath the tree."

The globe thistle provides an important metaphor allowing us to see a contrast in the natural course of things. It is the same in our interactions

between people. The Globe Thistle, in its youth, is thorny and prickly, something we may try to avoid. Yet at maturity, the globe thistle produces soft, delicate down-fiber that lifts its seeds into the air where it is free to find fertile ground elsewhere. At maturity, the gentle down of the great globe thistle is something that we use to pad our seats while we sit at length, comfortable while we deliberate great issues.

The Globe Thistle Basket reminds us that throughout the World there are many pointed issues of contention that can easily divide our people. When we can sit and deliberate each issue with a good mind and with the intention of taking the time that is required, we will have a peaceful resolution.

Onenhakenhra Spirit Basket

When our people began cultivation of corn, we were able to sustain a community, a nation, and a great confederacy of nations that allows for the participation of all our people in its governance. Onenhakenhra was the sustenance that allowed us to grow as a people with a free and participatory democracy that embraces ideas of peace for all mankind.

Essential in this governing structure is the role of women. Women planted the corn and tended the gardens. They are the ones vested with the responsibility of caring for the land and sustaining the people. Therefore they are regarded as the ones who hold the land. A great deal of life's nourishment comes from women, and for that we should be grateful. Nourishment comes from their breasts when we are born, from the food that they gather from their gardens, and from the wisdom they provide throughout our lives.

Likewise, within our Great Law of Peace, it is recognized that the women have essential roles to play. They are the ones who give birth to the children, who are then instructed properly about our laws, customs, and ways of life. Women are therefore given the special position known as Ioianer, or Clan-mothers, within our nations.

It is acknowledged that the Clan-mothers will choose the men to sit in leadership positions for a lifetime of service, because they are the ones who watched them as they grew. Furthermore, it is the responsibility of the women to ensure that the men who hold the Roianer, or chief leadership, titles will follow the laws of the people for their entire lifetimes. If a Roianer should stray from the proper path, it will be the women who have the responsibility to remove him from leadership.

The Spirit Basket takes the shape of corn and is represented as a female spirit, to acknowledge the role of women in our lives. On this basket the curled embellishments represent the corn kernel seeds of democracy. They may be manifested in the multitude of people everywhere, who may now take on essential roles in passing on ideas of peace throughout the world. Each generation of corn and people assists in the proliferation of this original idea and original good spirit.

Our thanks go the Onenhakenhra spirit for allowing us the privilege of forming a style of governance that has served us for millennia. Our thanks and greetings go to the spirit of Onenhakenhra in songs and in ceremonies that we celebrate throughout the year and each time we enjoy our traditional corn meals.

Let peace travel with each of us, wherever we go throughout the World.

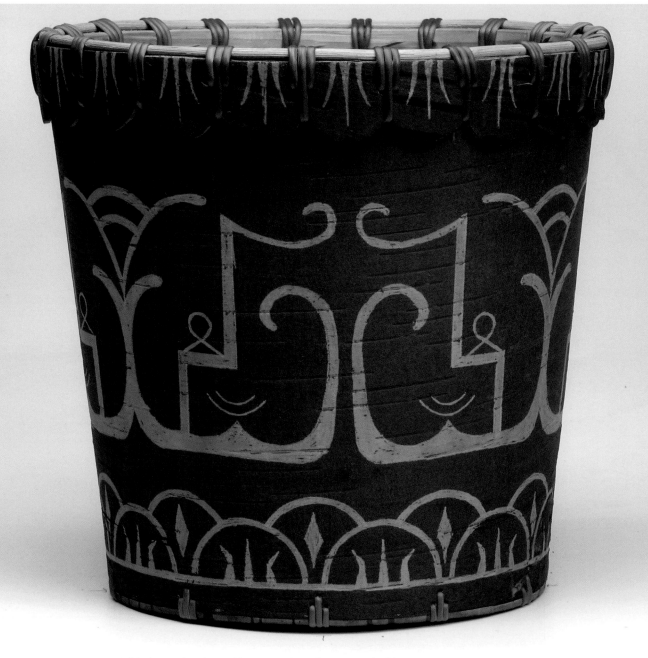

Birchbark container by David Moses Bridges, photo © Darel Bridges

Miniature basket by
Jennifer Neptune, photo
© Martin Neptune

WABANAKI TRADITIONAL ARTS: FROM OLD ROOTS TO NEW LIFE

Jennifer Neptune (Penobscot)

We are the Wabanaki, the People of the Dawn. Comprised of the Maliseet, Micmac, Passamaquoddy, and Penobscot, our home is in the east where the rising sun first greets the lands of what are now known as Maine, New Brunswick, and Nova Scotia. While each tribe has distinct territories and governments, we share similar beliefs, languages, art forms, and traditions.

Our traditions tell us that we have always been here. In one of our Creation stories the people were literally born from the ash tree—the basket tree—dancing and singing. For at least 12,000 years, our people have been in this land creating beautiful objects from the resources surrounding us.

The years following European contact were challenging times. Disease, wars, collapse of the fur trade, loss of land, and the lumber industry changed our people's lives forever. Rivers were dammed, cutting people off from runs of salmon and other migrating fish. Old-growth forests were cut down for lumber and to clear large tracts of land for farming. Settlers and lumber crews slaughtered the moose and deer populations. Habitat loss and over-hunting pushed the woodland caribou to extinction. The forests, fish, and animals the Wabanaki had depended on for thousands of years were decimated, and our people found themselves forced to adapt to an economy based on cash. Through these incredibly hard times, the Wabanaki turned within, to their art and creativity in order to survive.

Beginning in the 1700s, making and selling baskets and other traditional art forms became a means of survival that still allowed for the freedom to continue traditional ways. Families often traveled together, making and selling baskets, herbal medicines, birchbark boxes, beadwork, and elaborate carvings. The Penobscot, Passamaquoddy, Micmac, and Maliseet people are known to have traveled by foot, horse, train, birchbark canoe, and steamship to places as far away as Boston, New York City, and Philadelphia to sell their wares.

From all this change, new styles were created. Fancy baskets of ash and sweetgrass were made to fit every imaginable need. Baskets were made for storing hats, gloves, handkerchiefs, stationary, calling cards, jewelry,

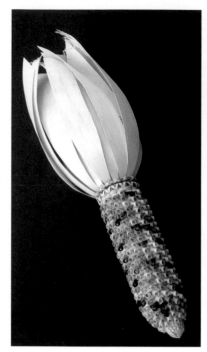

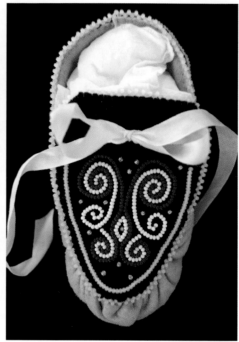

Corn basket by Theresa Secord, photo © Martin Neptune

Beaded moccasin with double curve design by Jennifer Neptune, photo © Peter Dembski

buttons, candy, yarn, knitting needles, thimbles, scissors, and needlework supplies. Baskets were made in the shapes of fans, purses, hats, napkin rings, pincushions, bookmarks, baby rattles, and teacups. Baskets that are still sought after today—shaped like corn, pumpkins, strawberries, sea urchins, pinecones, and acorns—originated during this time. Beadworkers took ancient designs that in the past had been painted or painstakingly stitched in porcupine quills, and used silk ribbon and beads to transform them into exquisitely beaded clothing, moccasins, hats, bags, watch pockets, tea cozies, and pincushions. Double-curve designs were transformed into brilliantly colored floral patterns inspired by medicinal plants and flowers. Men made canoes, paddles, snowshoes, and intricately carved root clubs, canes, crooked knives, and basketry tools.

Traditional artists became bridges between what had been and what was yet to be. The work we create as artists connects us with our ancestors and leaves behind a connection for those yet to be born to remember who we are and were. The baskets, carvings, beadwork, tools, and items that made their way into museums still speak to us and teach us. As traditional artists

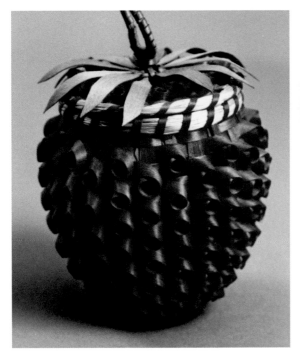
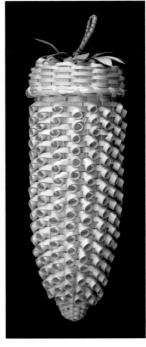

we feel a responsibility to create to the best of our abilities items that will make our people proud and represent our tribes in a positive way. We listen to the whispers of the past, combine them with our creativity in the present, and hope that what we leave behind will speak to the hearts of our people in the future.

While so much in our world has changed, traditional art is still an important part of our culture. If our ancestors were to return today, they would not recognize our clothing, cars, or housing, but they *would* recognize the artists and their ways. In our communities they would still hear the rhythmic sound of an ash log being pounded for baskets, smell the sweetgrass and freshly split ash in the basketmakers' homes, watch with pride as carvers transform birch roots into war clubs; they could go for a spin in a freshly made birchbark canoe, savor a steaming hot bowl of fiddleheads, moose stew, or hulled-corn soup, and finish off the day sitting around the fire laughing at old stories while listening to our drummers sing our ancient songs.

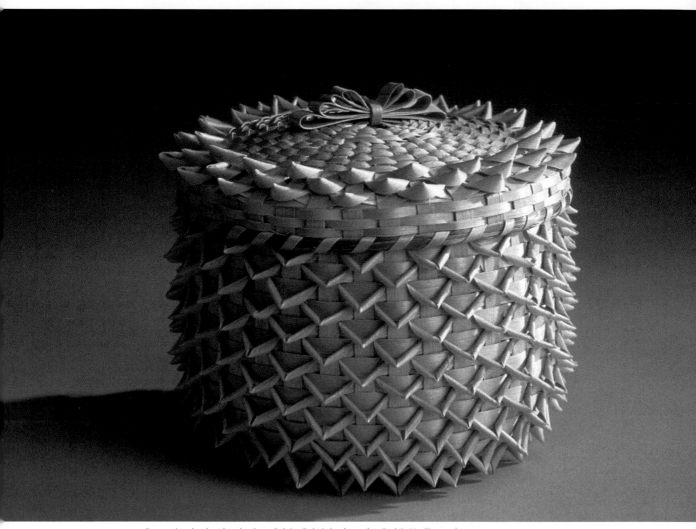

Porcupine basket by the late Sylvia Gabriel, photo by Cedric N. Chatterley

THE MAINE INDIAN BASKETMAKERS ALLIANCE
Theresa Secord (Penobscot)

Glooskap came first of all into this country, into the land of the Wabanaki, next to the sunrise. There were no Indians here then. And in this way he made men: He took his bow and arrows and shot at trees, the basket trees, the ash. Then Indians came out of the bark of the ash trees.
—Wabanaki creation story told by Molly Sepsis, published in *Algonquin Legends* by Charles G. Leland

From pack baskets woven with curved bellies to fit the sides of our birchbark canoes, to fancy Victorian art pieces or potato baskets for the harvest in Aroostook County, Maine Indian baskets have embodied a way of life and identified us as Woodland people.

Although I grew up in a family of talented basketmakers, I first became aware that, after hundreds, perhaps thousands of years, our knowledge of basket making was slipping away when I apprenticed with Madeline Tomer Shay, one of the last fluent speakers of the Penobscot language and a revered basketmaker. At the time, I was one of only a dozen Maine Natives under the age of fifty who were making traditional ash and sweetgrass baskets. When Madeline Shay passed on in the early 1990s, I became determined not to watch traditional basket making die as well.

In 1993 we formed the Maine Indian Basketmakers Alliance, a Native American arts service organization dedicated to preserving the ancient traditions of ash and sweetgrass basketry among the Maliseet, Micmac, Passamaquoddy, and Penobscot tribes of Maine. In 2003, our ten-year anniversary, we were honored with the International Prize for Rural Creativity for lowering the average age of basketmakers from sixty-three to forty-three. Ours is a story of self-determination, as we have increased the number of younger people taking up the tradition, effectively saving the ash and sweetgrass weaving traditions—at least for the time being.

But now there are new challenges. Because indigenous basketry is heavily natural resource dependent, when the environmental balance is

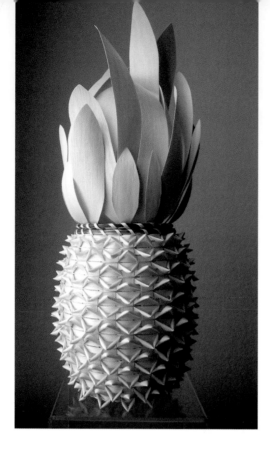

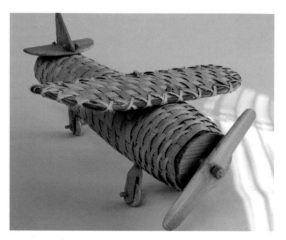

Pineapple basket by Jennifer Neptune,
photo © Martin Neptune

Ash airplane by Lola Sockabasin,
photo © Jere DeWaters

upset, this holistic art form and an entire way of life is threatened. In the eastern Great Lakes states, the emerald ash borer, an invasive pest from Asia, is killing all of the ash trees. As the beetle has moved east, the Maine Indian Basketmakers Alliance Board of Directors has moved to document all aspects of our tradition in order to provide instructions for future generations, in case our ash trees are lost.

Another issue we face is that of intellectual property rights. A few years ago, the president of design for a mass-produced midwestern basketry company came to a museum in Maine to study basket designs and weaving styles. We fully expect to see our weaves on the home shopping channels sometime in the future as a result of this visit. More recently, the website of a large discount home-design chain store showcased a basket for $12.95— a basket that features our porcupine weave, a traditional weave used by the Wabanaki, Haudenosaunee, and Great Lakes weavers.

As a nonprofit organization, we're working toward preserving our basketmaking tradition and paving the way for future weavers. We are located in Old Town, Maine, on the Penobscot River, where the Alliance operates the Wabanaki Arts Center Gallery. The gallery features the work of over a hundred artisans, several of whom are included in *North by Northeast*. The

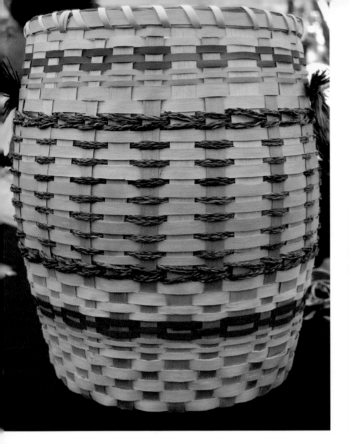

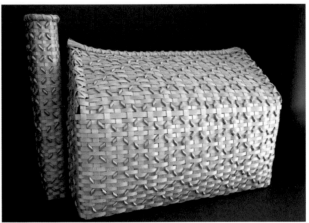

Barrel basket by Carol Dana, photo © Peter Dembski

House by Rocky Keezer, photo © Peter Dembski

gallery stimulates art making and provides the only year-round retail outlet for tribal baskets and art in New England. It also helps us raise sustainable revenue for nonprofit programming such as our Traditional Arts Apprenticeship Program, Tribal Basketry Community Workshops, and MIBA events, as well as retail markets such as the MIBA Basketmakers Gathering and Native American Festival in Bar Harbor (celebrating our fifteenth in 2008), the Common Ground Fair in Unity, and the holiday market at the Hudson Museum in Orono. The annual coastal gathering at the College of the Atlantic in Bar Harbor is held at the historic location where our people spent summers fishing and gathering shellfish, sweetgrass, and the other bounties of the coast, and where, in the 1800s and through much of the last century, we still sold our baskets.

As Native American artists, we celebrate where we have been and look forward to where we are going. At our gathering in Bar Harbor, I remember a colleague purchasing a brown ash model biplane made by Lola Sockabasin, an elder and Passamaquoddy basketmaker, and asking me, "Is that contemporary?" I said, "Yes, we have always been contemporary. There will be more basketmakers after us and they will be contemporary, too."

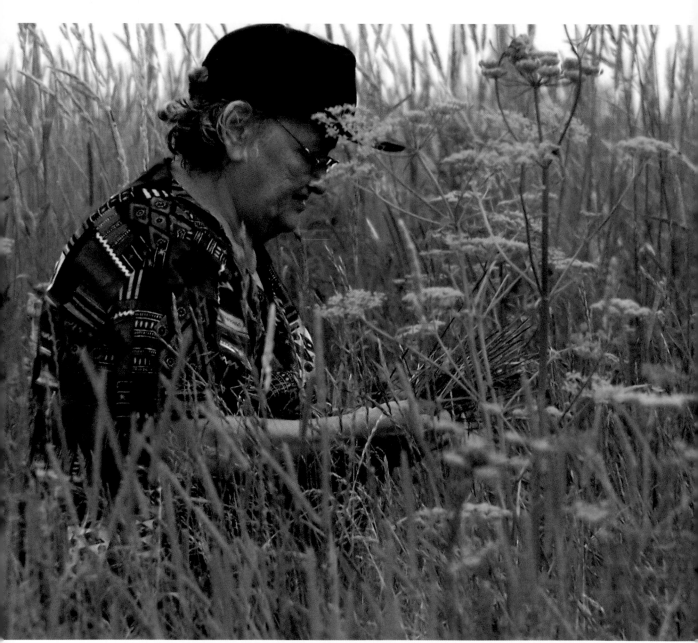

Florence Benedict collecting sweetgrass, photo by Salli Benedict

THE MATERIALS

"Native symbols and art remind us of our own and nature's origin and the kinship of the natural and human worlds. Oral traditions and ceremonies remind us that we are part of the sacred circle of life and that we have an obligation to all that surrounds us."
—Butch Phillips, Penobscot birchbark artist

For centuries, the Haudenosaunee and Wabanaki people have made baskets, boats, canoes, lacrosse sticks, walking sticks, snow snakes, snowshoes, seats, tools, drums, root clubs, pack baskets, fishing creels, and birchbark containers and shelters from the bounty of the northern forest.

Mindful of what grows where and when, traditional artists are deeply connected to their place. This relationship is revealed in the particular: knowing just which tree to use or when to pick sweetgrass. Passed on from one generation to the next, this knowledge is acquired over a lifetime of practice.

"Basket making is an occupation as well as a form of art. It is also about conservation and respect for nature. The ash is harvested by family, finished by myself and my children and grandchildren, and woven with the knowledge I learned and what I imagined and invented. The sweetgrass comes from our land; it too is about our roots and our history. Basket making to me is about our respect for using the bounty of nature and the talent of generations in making it into something of value, beauty, and function."
—Molly Neptune Parker, Passamaquoddy basketmaker

Haudenosaunee and Wabanaki artists continue to craft their work out of ash, birch, and sweetgrass. Long before the weaving, carving, or boat-building begins, Wabanaki and Haudenosaunee artists first must find their materials. For many, this is the most demanding part of the process.

As the late Micmac woodcarver, Wolf Sanipass, put it, "The most important part of going in the woods is picking the right materials. You should have the eye to see what you are looking at. I can walk in there and find trees. Looking at the bark tells you a lot; straight, very straight grain tells you a whole story."

Basket Trees

Wabanaki craftspeople call it brown ash, the Haudenosaunee, black ash. The botanical name is *Fraxinus nigra*. To basketmakers, it is the "basket tree" because it provides the best natural material for making splints, the pliable strips of wood used for weaving baskets.

A slow-growing tree, black/brown ash grows in the wild, in bogs and swamps or along streams. The tree "likes its feet wet" and needs lots of water to produce flexible strands for weaving baskets. Relatively common, *Fraxinus nigra* thrives in rich, moist soil and can reach 50 to 60 feet in height and 10 to 20 inches in diameter. One mature tree can produce up to a hundred baskets.

Many basketmakers have a trained eye for picking out a good tree. "I guess finding a good tree is like a mechanic picking out a good car. It's experience, and doing it over and over and knowing what the wood is going to be like," explains Micmac basketmaker Richard Silliboy.

The knowledge of what makes a good basket tree is traditionally the purview of men. Now in his seventies, Mohawk basketmaker Henry Arquette still remembers what his father and grandfather shared with him about finding black ash at Akwesasne: "You have to look where the tree is growing. Don't pick a tree near cedar because it will affect the quality of the wood."

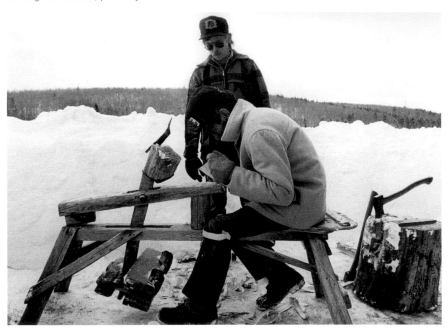

Ash logs for baskets, photo by Kathleen Mundell

The late Micmac woodcarver Wolf Sanipass with John Philbrook, photo by Cedric N. Chatterley

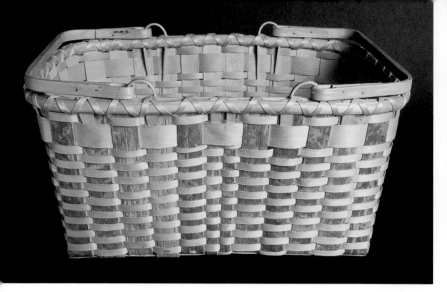

Henry Arquette, Atsienhanonne Mohawk/Snipe Clan

Henry Arquette remembers that when he was growing up in Akwesasne, the sound of men pounding black ash logs for baskets could be heard from miles around. His roots in the Mohawk community of Akwesasne run deep. He is a Mohawk speaker, retired ironworker, and master utility-basket maker. His grandfather first got him started in work baskets by having him make small pack baskets. Later, his father taught him how to find just the right tree for baskets and how to pound ash.

Henry Arquette grew up to become a renowned basketmaker specializing in pack, laundry, picnic, wedding, and corn-washing baskets. A patient and well-respected teacher, he has shared his skills with many people at the Akwesasne Museum in Hogansburg, New York. Arquette's mastery of ash splint work baskets helps keep the tradition alive of making utility baskets at Akwesasne.

Each basketmaker has specific techniques for locating trees. Eldon Hanning, a Micmac basketmaker who provides most of the ash for Maine's basketmaking community, likes to carry a pair of binoculars to check out the tops of the trees. "Over a period of time, I can tell by the color of the leaves, by the shape of the limbs. In the springtime, ash is the last tree to have leaves on it, and in the fall, it's the first tree to lose them. After awhile, you can pick out an ash tree pretty easily. . . . It's in my blood."

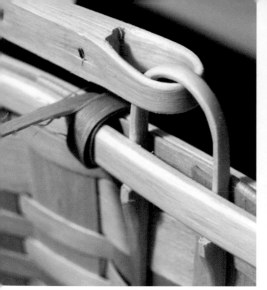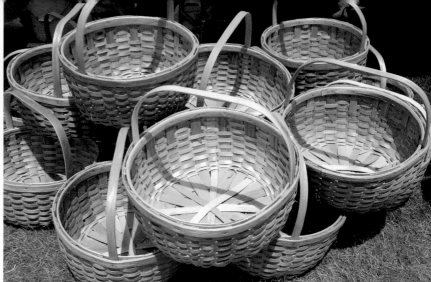

Growing up in Aroostook County, Maine, Hanning remembers going out with his family to collect ash in the North Woods. "We were five, six, seven, eight, and we would pull three-foot logs out of the woods. We couldn't pull very many, but we would get them out of the woods. Sometimes the snow would be deep and we would build a bonfire while the adults cut logs. The whole family was involved in it. It was a lot different doing it then than it is now because back when I was a child, the family was together, it wasn't, 'I'm not going to help you today, I'm not going to do that.' Everybody was helping the family do what they were doing."

When harvested, one ash tree can weigh well over 100 pounds. Getting the tree out of the woods requires both experience and strength. As Micmac basketmaker Richard Silliboy explains: "Basket making is very hard work. Utility baskets, like the ones I make, use a lot of brown ash. Because of the amount of ash that is used to make utility baskets, we need to learn how to go out into the woods and select trees that are suitable for basket making. This is an art all by itself, an art that is known by very few people. There are probably less than a handful of Micmacs living in northern Maine who could go into the woods and select good basket wood."

Opposite page: Picnic basket by Henry Arquette, photo © Peggy McKenna
Henry Arquette, photo © Peggy McKenna

Above: Henry Arquette basket handle, photo © Peter Dembski
Potato baskets by Eldon Hanning (Micmac), photo © Peter Dembski

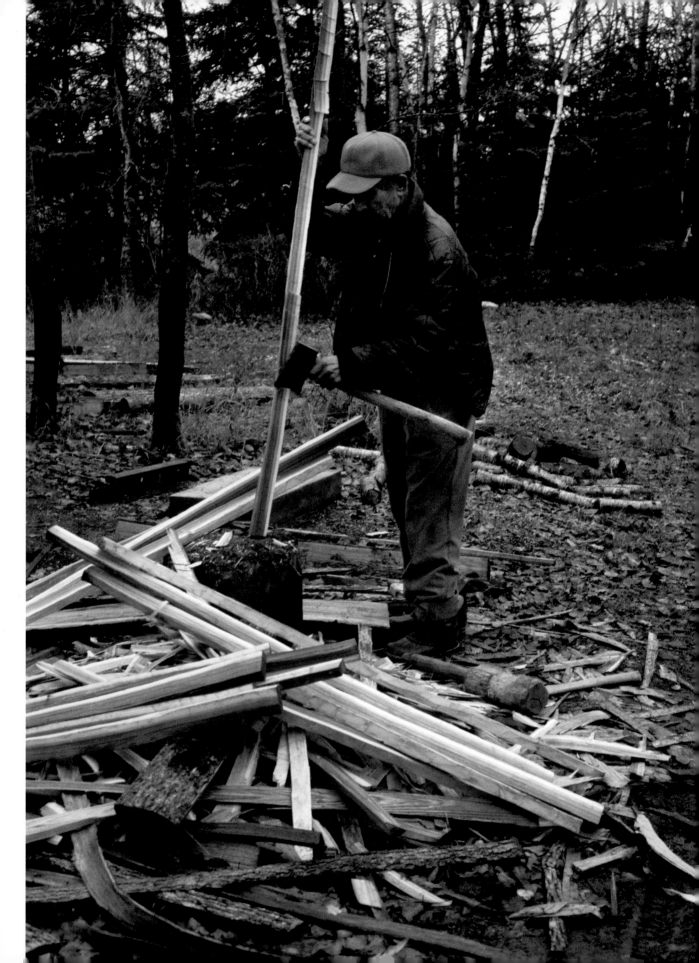

Donald Sanipass, Micmac

The late Micmac basketmaker Donald Sanipass recalled helping his elders get ash in the woods of New Brunswick, Canada, on the Shedeac Reserve. "I started way back when I was a young fellow, very young, by looking at my parents and other basketmakers sitting around. I wasn't asked to make baskets, but I could see what they were doing, and in later years, when I got a little stronger, I used to help the elders carry out the wood, the ash wood, for miles in the woods. They would cut it down with a crosscut saw and let every-body have a bundle. They would tie it up and you would have to walk five miles to go back home, or wherever the vehicle was, and it was hard for me. You know those old guys can really go, and I was always way behind trying to catch up."

When Donald Sanipass moved south to Maine, he contin-ued to work with his family making baskets. His wife, Mary, also a renowned basketmaker, remembers logging with Donald in the woods and getting ash for basket making. "Don would go out early in the morning. He would take off, get my horse ready for me and put the bridle on my horse, and he would cut down trees. After I fin-ished getting the kids to school, I would take my horse out. He used to have ten trees by the time I'd come along."

Donald Sanipass would go on to become a tribal chief and the first president of the Maine Indian Basketmakers Alliance.

"Basket making has always been part of being Micmac," he said. "It was the basket making that helped us get tribal recognition. We have always worked on saving the brown ash tree and making sure that younger people are learning how to make baskets."

The late Donald Sanipass pounding ash, photo by David Sanipass

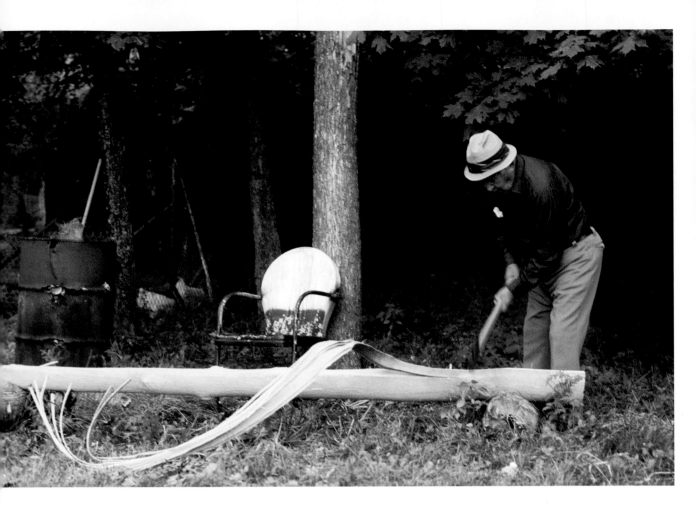

Tom Ransom pounding ash, photo courtesy of Akwesasne Museum

"In an age of Nintendo and computers, will our children ever understand the joy of pounding a log after school and wondering at the way the splints rise off the log?"
—Henry F. Lickers, Director, Department of the Environment, Mohawk Council of Akwesasne

Once the tree is taken out of the woods, it is then trimmed and peeled. Although styles of ash preparation vary among the different tribes, the basic "pounding" is a constant. The trunk of the tree is hit repeatedly with the blunt edge of an axe, causing the wood to separate along its annual growth rings into thin layers. These layers are then trimmed and shaved into strips for weaving. If the tree is healthy, the wood is light, strong, and elastic. If not, the growth rings are dry, brittle, and dark.

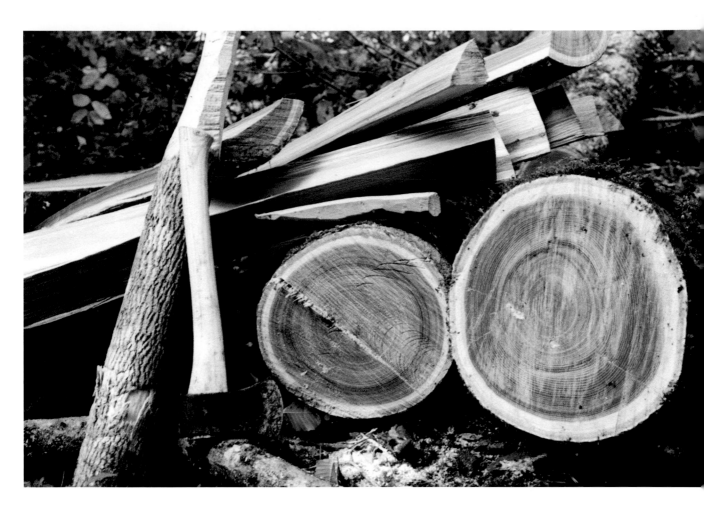

Today, a healthy brown/black ash tree is a rare sight in the North-
east. In a stand of a hundred trees, ash collectors report that as few as two or
three are suitable for basketry. Much of the wood is too brittle to weave.
Basketmakers attribute the poor quality of ash to various sources of environ-
mental degradation—acid rain, groundwater pollution, clear-cutting practices,
insect damage, and disease. The most recent threat to the tree is the emerald
ash borer beetle which is slowly moving east from the Great Lakes.

Since 1990, Haudenosaunee and Wabanaki foresters, environmental
advocates, and basketmakers have been working to develop strategies to
ensure the tree's survival. In 1994 the Maine Forest Service found that more
than half of the trees surveyed had a minimum of 20 percent dieback. By taking
tree cores, which indicate the amount of a tree's growth each year, scientists
and tribal foresters in Maine and Akwesasne have found that within the last
twenty years, the growth of the basket trees has been decreasing.

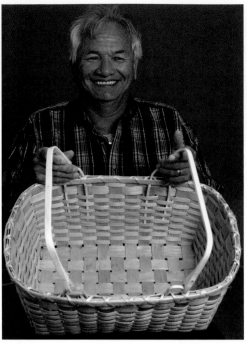

Richard David splitting ash, photo © Peter Dembski
Richard David, photo © Peggy McKenna

Richard David (Tehawenneke), Micmac/Eel Clan

Richard David, a member of the Eel Clan, is one of a family of thirteen children with roots in Akwesasne, New Brunswick, and Nova Scotia. "My father was Mohawk and my mother was Micmac, both basketmaking First Nations." David is now the assistant director of the Mohawk Council of the Akwesasne Department of Environment. David's interest in the plight of the black ash tree began when he listened to the concerns of elders and fellow basketmakers. "You can't separate the tree from the tradition. How long the supply will last directly affects the tradition. There is a pragmatic as well as a long-term interest by basketmakers about the health of the tree. In Akwesasne, the building of dams in New York got all the trees flooded out. Now we have to leave the St. Lawrence Valley to find suitable ash."

As a basketmaker and an environmental advocate, Richard David has been working with Les Benedict, the assistant director with the St. Regis Mohawk Tribes' Environmental Department on studying the habitat and growth habits of black ash. Les Benedict's work with black ash began in 1991 with the Akwesasne Task Force on the Environment (ATFE). Together, David and Benedict have

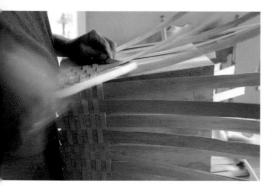 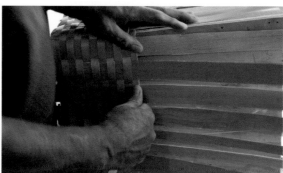

written the *Handbook for Black Ash Preservation, Reforestation /Regeneration.* They also travel throughout the region researching the health of existing stands of trees and planting ash seedlings.

"Les Benedict and I have been collecting black ash seeds for fifteen years now," David says. "We are responsible for putting about 60,000 seedlings back into First Nation territory and in Ontario, Quebec, and New York State. We start out with a big number and we end up with a few good trees. If we prepare a hundred seeds, we are lucky if we get eight trees planted in three years."

A student of Henry Arquette, Richard David sees the problems in finding suitable ash as having a direct impact on the tradition as well as on his own basket making. "For a whole year, I wasn't able to make baskets because there weren't any supplies and I didn't have time to get my own log. The worst part about it is that handing the knowledge to the children and the grandchildren slows down, too. If my mother is making baskets and she only has a limited amount of material, she is not going to use that material for one of her grandchildren to practice on because she needs that material to make a finished basket she can sell."

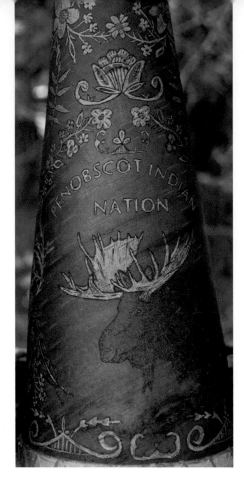

Birchbark moose call by Butch Phillips, photo © Peter Dembski

Birchbark container by ssipsis, photo © Peter Dembski

Opposite page: Birchbark container by David Moses Bridges, photo © Darel Bridges

White Birch

Northeast Woodland people traditionally used the bark of the white birch tree for just about everything—wigwams, canoes, baskets, animal calls, quivers, buckets, cooking utensils, and even containers for collecting maple sap. Sometimes called paper birch, the bark of this beautiful tree is still sought after because it is waterproof, flexible, and very resilient.

To the uninitiated, all white birch trees look alike, but to practicing traditional artists, only certain trees will do. White birch grows in rich, moist soil, usually along the banks of lakes, ponds, and rivers. The outer bark of a paper birch is white and rough. Depending on the season, the inner bark can be either dark or pink and smooth. This waxy inner bark provides a durable cover that is both insect- and water-resistant.

Winter bark, the dark brown underside collected before the sap runs, is primarily used for building canoes and shelters. The rich color can also be a canvas for etching decorative patterns and designs. Spring and summer bark can be shaped into beautiful containers, traditionally decorated with porcupine quills, moose-hair embroidery, or etched or painted designs.

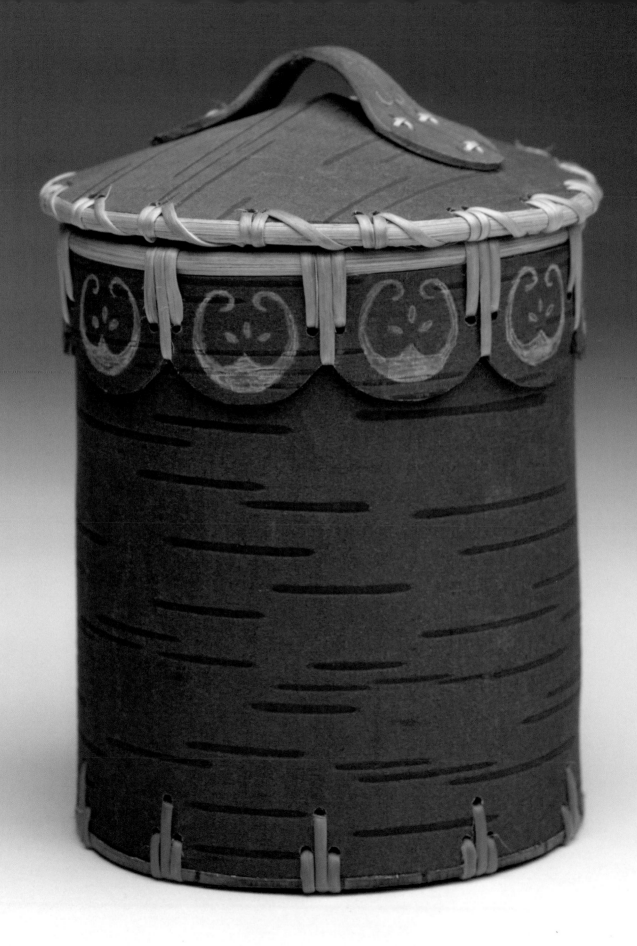

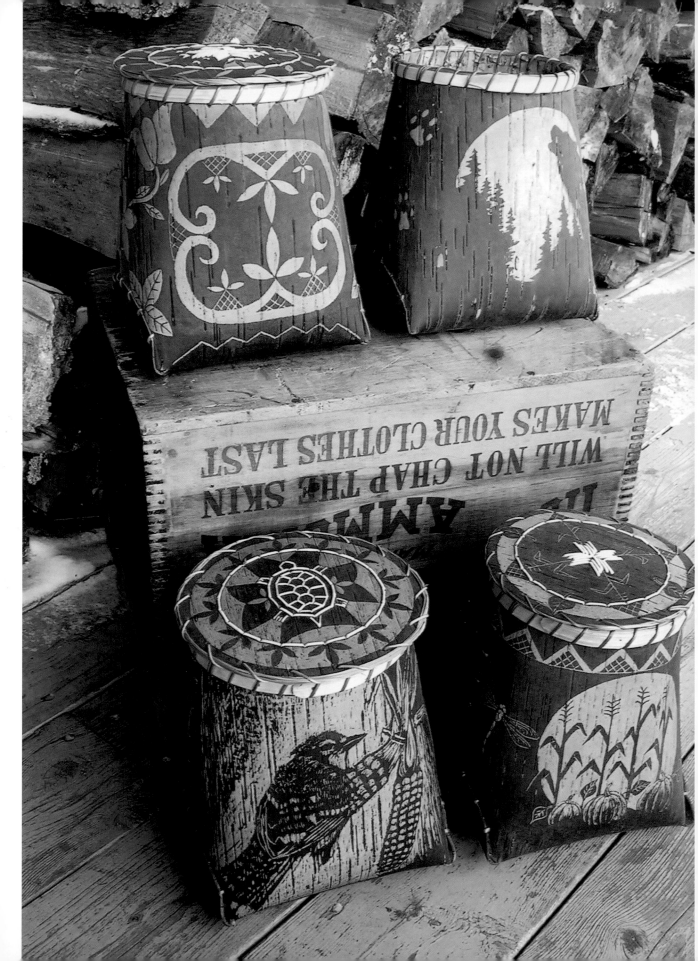

Opposite page:
Birchbark containers by
Barry Dana, photo by
Lori Dana

Barry Dana, photo by
Marilyn Rogers

Barry Dana, Penobscot

"I would guess that the oldest form of native basketry is the folding and sewing of bark taken from the white birch tree. When bark is taken from the tree in early fall and late winter, it comes off with an extra dark layer known as the red cadmium layer, or winter bark. When it's moistened, you can scrape into this layer, revealing the brighter yellow surface known as summer bark. It is the winter bark/summer bark contrast that allows me to etch both traditional floral and double-curve designs, as well as contemporary art forms such as animal and human faces. My baskets are made of birchbark, sewn together with spruce roots, and held to form by cedar rims. The lids are often adorned with porcupine quills, sweetgrass, and additional etching.

"There are probably a thousand and one uses of birchbark, from making bowls, cups, and baskets to building canoes and wigwams. A birchbark canoe is really the ultimate, because the canoe is made of one sheet of bark. You spend an enormous amount of time in the woods searching for the right tree. I've actually come across white birch that someone peeled forty or fifty years earlier. My first thought was 'this is my ancestors.' I'm out here doing what they did and I get a big kick out of that.

"I have taken the time to revitalize the skill of making traditional Abenaki/Penobscot etched winter-bark buckets. These buckets were traditionally used as food-storage containers. Makers would etch double-curve and floral designs on the outside as decoration.

47

White birch, photo
© Peter Dembski

Porcupine quills were embroidered at times most elaborately on the lids, and sometimes completely covered the entire basket.

"As a Native artist, it is difficult to maintain the tradition of birchbark basketry. One cannot purchase bark, roots, or cedar. One must travel far and wide in search of quality bark. Searching and gathering is demanding and challenging. I spend much time exploring the woodlands of northern Maine in search of quality bark and cedar. Quality bark is rare these days. Huge logging companies search out the best birch trees for veneer lumber. I am left searching where their huge harvesters can't go, close to waterways where no roads exist."

The former chief of the Penobscot Nation, Barry Dana is an environmental and cultural advocate. "Because I'm Penobscot, I'm bound to be a steward of the land, the air, the water, and the plants and animals. If I gather a birch tree or a cedar, I know—based on my traditions—that I am affecting the next seven generations. So whatever I do, it must be better than today so that in seven generations, they can do the exact same thing I'm doing."

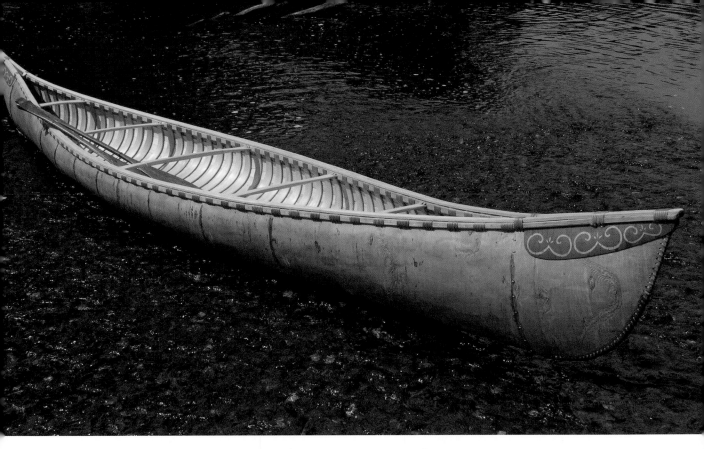

Birchbark canoe by
David Moses Bridges,
photo © Darel Bridges

White birch is the first choice for making canoes. Lighter than other woods, birchbark has been used for centuries to build canoes. The birchbark canoe allowed Native peoples to navigate the vast network of rivers, lakes, streams, and ponds of the Northeast. Unlike the typical European boat, these sleek vessels could be carried from one watershed to the next, and could be poled through rapids and shallow waters. During the eighteenth and nineteenth centuries, Native American guides helped non-Native traders, surveyors, explorers, hunters, trappers, and sportsmen explore the waterways and interior forests of the Northeast by canoe.

Canoes are still being made in the Penobscot River Valley of Maine by the world's largest canoe maker, Old Town Canoe. Although most are now constructed out of various plastics, the wood-and-canvas canoes they have made for so many years are directly descended from the birchbark canoes made by Penobscots on nearby Indian Island, and many of the synthetic canoes follow the traditional form.

Traditional birchbark canoe makers like to use large, smooth trees. But finding such a tree today—so that the canoe can be made from a single piece of bark—is a formidable task. White birches continue to be cut for lumber and paper, making mature, full-sized trees a rare sight in the Northeast.

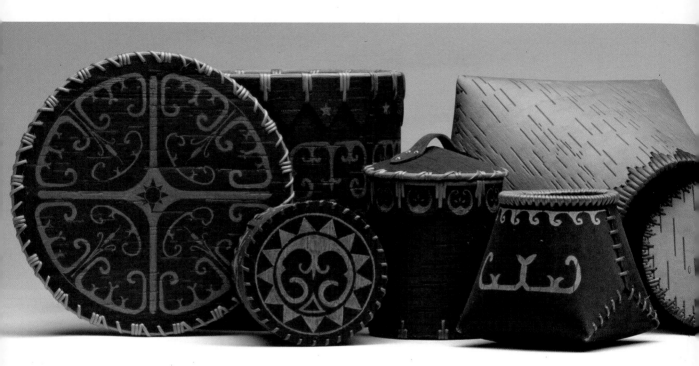

Birchbark containers by David Moses Bridges, photo © Darel Bridges

David Moses Bridges, Passamaquoddy

David Moses Bridges, a Passamaquoddy birchbark canoe maker and birchbark artist, learned about canoe making from his grandfather, Sylvester Gabriel. A respected guide and canoe maker, he built his last canoe in 1920. "My grandfather was the last of the old-time makers in Maine and he lived with us when I was younger," David remembers. "This was back in the days before daycare, so while my mom and dad worked, he was always there and we just talked an awful lot about all kinds of things. He knew all the old stories and legends, and he mentioned just in passing one time that he used to make birchbark canoes. At the time, I was reading *Stuart Little* and he has a little birchbark canoe in the story. I was probably six or seven years old, and we just decided right then and there that we would make a canoe someday."

But Sylvester Gabriel passed on when David Bridges was just ten, leaving behind his tools, his love of birchbark canoes, and his inherent "good eye for birch." "My grandfather left me all his old tools—his crooked knife, barking knife, drawknife, awl, and axes. Those are the primary canoe-making tools, right there. You just need this bare-bones set of tools and a good eye."

David Moses Bridges went on to study marine drafting, and apprenticed for many years with master birchbark canoe maker Steve Cayard. Bridges also assisted Cayard in documenting and restoring historic canoes. "Birchbark canoe construction has been a lifelong interest of mine. Many of the traditional crafts were passed to me from my family and members of my community at Sipayik. With the death of my grandfather, my nation's last resource for bark canoe construction passed away. Though we often spoke of building a canoe together, he was too old and I was too young. In the end, I was left with his canoe-making tools and the desire to learn."

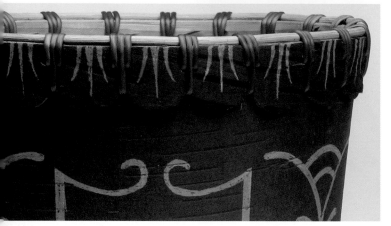
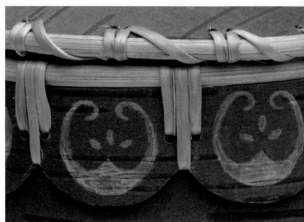

Details of birchbark containers by David Moses Bridges, photo © Darel Bridges

Through David's own efforts, his family's legacy has been shared with the entire Passamaquoddy community. "In the community up at Pleasant Point, I still speak with a lot of people—some of the elder men who used to go out birchbark hunting with my grandfather, as well as my own folks. They always have great stories about how he worked, how he would bring his patterns into the woods with him and cut the bark around the campfire that night so he wouldn't have to carry the excess out. As I hear these stories, they reflect the way in which I work now. It is almost like it has come full circle."

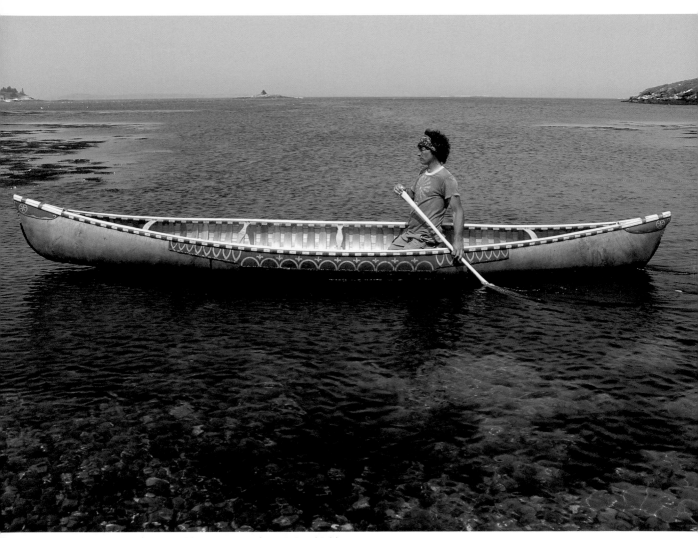

David Moses Bridges in canoe, photo © Darel Bridges

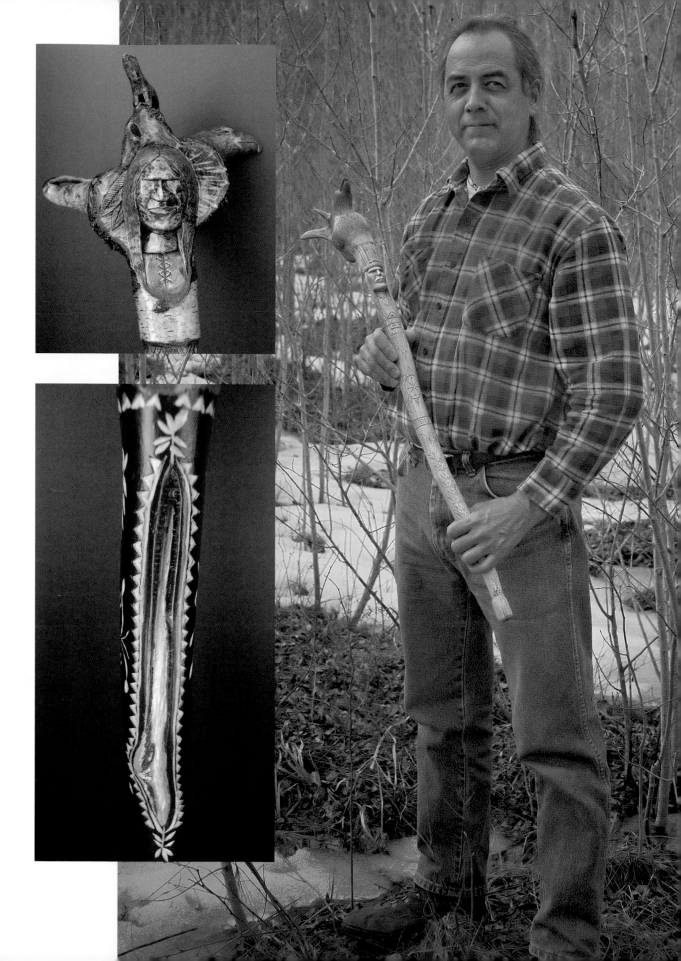

GRAY BIRCH

Penobscots have used the roots of the gray birch for centuries to carve clubs. Originally carried as symbols of one's status in the tribe, these ceremonial root clubs began to be appreciated by Native art collectors in the late 1880s. Today, root clubs are still a source of creative expression and cultural identity.

Stan Neptune, Penobscot

Stan Neptune of Old Town continues the tradition of building ceremonial root clubs. As a young man, he studied with Penobscot master carver Senabeh Francis. Francis showed him how to "find his tree" and how to carve clubs. In turn, a generation later, Stan Neptune taught his son, Joe "Hugga" Neptune, who is now an accomplished carver in his own right.

The journey to find gray birch often takes Stan Neptune down one of Maine's most beautiful waterways, the Penobscot River. Young gray birch is harvested for root clubs by digging up the root system and then pulling the tree out of the ground. Once a suitable tree is found, the top is removed. Stan then washes the roots and trims off everything but the root heads. With knife in hand, he then shapes the roots into points, decorating them with spiritual, human, or animal faces

According to Neptune, the shape of the root helps define the club. Some will have eagle faces, others turtle or human. After the root ball is carved and sanded, Stan begins to carve the shaft by adding vines, leaves, flowers, and circles. "Carving a completed war club averages about forty to sixty hours. Each club requires patience and time to reveal itself to the carver."

Braided sweetgrass by Dianne Campbell (Passamaquoddy), photo by Cedric N. Chatterley

Florence Benedict braiding sweetgrass, photo © Peter Dembski

SWEETGRASS

Sweetgrass is a grass cherished by basketmakers for its pliability, color, and wonderful fragrance. Either woven a couple of strands at a time or braided, it is the signature element of many Haudenosaunee and Wabanaki fancy baskets. No matter how old and dry the sweetgrass, once it is wet, the delightful fragrance comes back, even on older baskets.

Sweetgrass is harvested in summer, and each blade is carefully picked by hand so as not to damage the grass. After it is gathered, the grass is cleaned either with the fingers or with a wooden comb to remove the stiff, dry pieces. It is then tied into bundles and hung in the shade to dry. Some of the grass will be stored for binding baskets and for making basket covers. Some of it will be soaked and later braided into skeins to be used in decorating fancy baskets. On average, it takes eight hours to braid 100 yards.

Many elders remember braiding sweetgrass together. As the late Passamaquoddy basketmaker Theresa Gardner recalled, "My mother, Elizabeth, was a basketmaker and my grandmothers on both sides were basketmakers. I used to go to sweetgrass parties with my mother. We would go house to house. People would talk and then they would braid for that person."

Having grown up in the Passamaquoddy community at Pleasant Point, Maine, Clara Keezer remembers how everybody worked together to make baskets. Some women had the job of finding sweetgrass, others combed, dried, and braided it. Some women wove the tops of baskets, using sweetgrass for the trim or parts of the weave. "By the time you finished a basket, everybody had contributed," she says.

These braiding parties were social occasions as well. "When I was about ten years old, about five or six ladies would be invited to a home and the person who was having the party would have everything ready, like the sweetgrass. She would furnish the sweetgrass so the other ladies could braid.

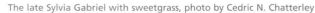

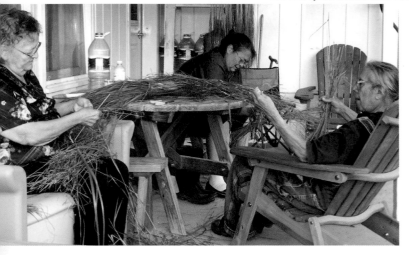

Sometimes they got done about nine o'clock at night, from six to nine. They would have prizes for whoever braided the best or the fastest. The prizes would be cakes or little knickknacks. The braid would go to the hostess; usually it would be about twenty-five to thirty yards long."

In nearby Princeton, Molly Neptune also remembers sweetgrass-braiding parties: "It was nice to watch all these women sit down and start braiding sweetgrass, and boy, what a beautiful sound. If you have at least half a dozen women braiding, all you can hear is humming and each one sounds different. That was the best part of it. The hostess would serve the goodies for that particular time. They would serve cakes or just fry bread with home-made jam, or even apple pies. I remember going to my aunt's house and I would see all these strings of apples where she dried them, so I would ask her, 'What are they for?' and she would say, 'Oh, they are going to be for my pies in the winter.'"

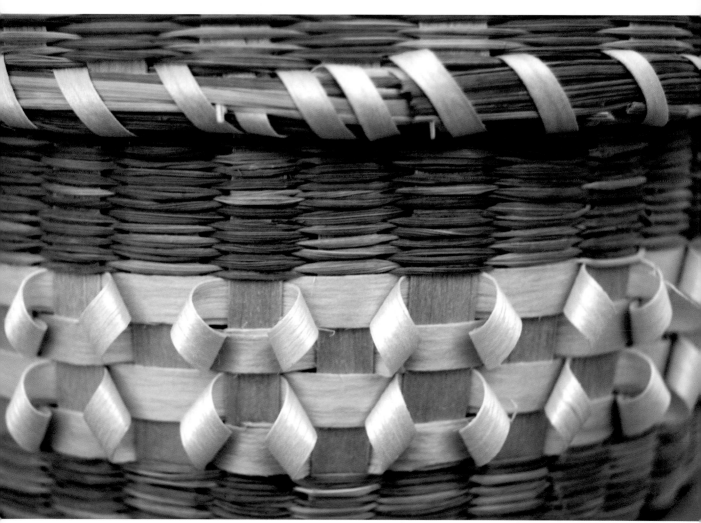

Sweetgrass and ash basket by Florence Benedict, photo © Peter Dembski

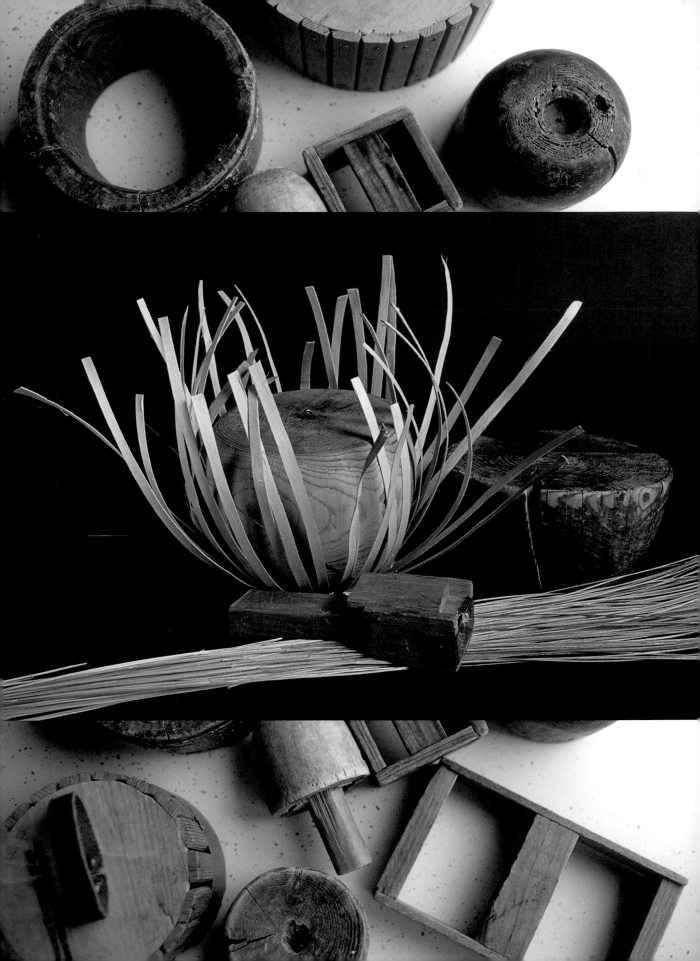

"Ash is the silk of the basket woods, in terms of the twists and the kinds of things you can do with it." —Theresa Secord

 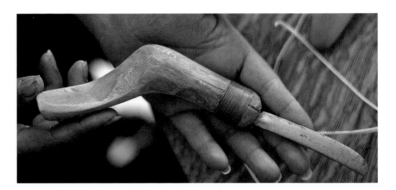

Sylvia Gabriel, the late master Passamaquoddy basketmaker, cautioned her students, "Weaving is easy, preparing your materials is the hard part."

Barbara Francis (Penobscot) weaving basket, photo by Cedric N. Chatterley

In order to weave the thick, pounded ash into usable basket material, it must first be made into thinner, smoother strips. As a rule, thicker ash splints are used in work baskets, while narrower, thinner splints are used in fancy baskets. Rough splints are split lengthwise using a handmade wooden V-shaped device called a splitter. The splitter is placed between the knees and the ash splint is pulled up through a slit in the top, what basketmaker Richard David refers to as "the original thigh-master machine." In this hard work, varied tension between the knees allows the ash strips to be evenly separated and smoothed. The splints are then scraped with a knife to remove rough outer edges.

Passamaquoddy crooked knife, photo by Cedric N. Chatterley

Opposite page: Penobscot basket molds, photo by Cedric N. Chatterley

After the ash is split, basketmakers use a tool called a gauge. This is another handmade tool, with a row of evenly spaced metal blades set into a wooden handle. The blades slice the trimmed ash into even narrower, more uniform strips. Gauges are hand carved and are often passed down through basketmaking families. The handles of many older gauges are elaborately carved with animals and double-curve designs.

Mohawk basket molds with gauge, photo © Peggy McKenna

Because different baskets call for different width splints, having a good collection of gauges is essential. A basketmaker may have as many as thirty different gauges in his or her workshop. Mohawk basketmaker Judy

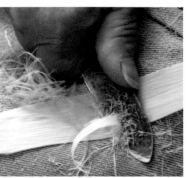

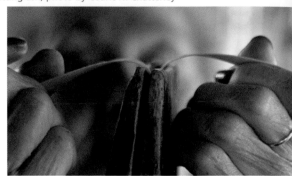

Cole remembers helping out her grandmother at a young age. "Our house was always full of splints and sweetgrass. My grandmother sat in the hall and everything was around her. I just kind of picked it up. She used to call me when she cleaned splints. She would do it by the bundle, probably eight to ten bundles, so when she got done cleaning and had to use the gauge to make her ribbons, she would call me to come and help her. She would sit on that chair, put the splint on the gauge, and I would pull it because those strips were like eight feet long. She would change these gauges—she had any size that she needed."

The width of splints to be cut by a gauge determines how many teeth the gauge has and how far apart the teeth are. Those with teeth close together slice splints into narrow widths; those with teeth farther apart cut wider ones. As Passamaquoddy basketmaker Rocky Keezer explains, "You have to feel the width, not look at it, but feel it. A master feels the materials and doesn't have to look." Such mastery takes patience and perseverance. Penobscot basketmaker Theresa Secord describes it this way: "It's a mess and it's a lot of work, but that's when you have achieved total control over the materials. You can make them whatever thickness you want. Sorting through the materials is also a big step, in that after you have split, you can actually pick through rather rapidly and feel with your hands—this piece is going to be good for a standard, this is for collar materials. It takes a lot of time to

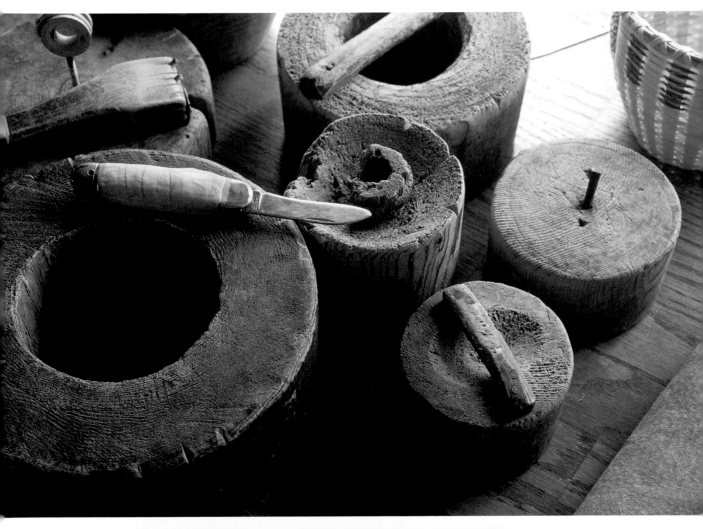

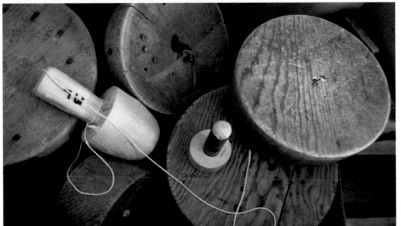

Penobscot molds and gauges, photo by Cedric N. Chatterley

Judy Cole's drawer of Mohawk basket molds and blocks, photo © Peter Dembski

63

Basket materials, photo
© Peter Dembski

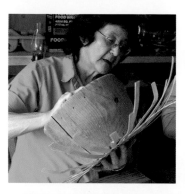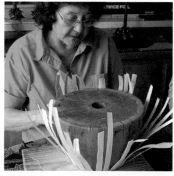

Molly Neptune with
basket block, photo
© Peter Dembski

Molly Neptune weaving
ash with block, photo
© Peter Dembski

Molly Neptune basket
block, photo © Peter
Dembski

Florence Benedict's
basket molds, photo
© Peter Dembski

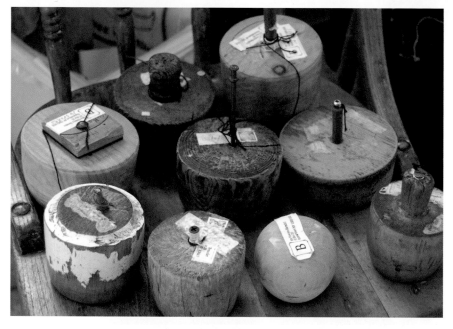

Wabanaki and Mohawk
basket gauges, photo
© Peter Dembski

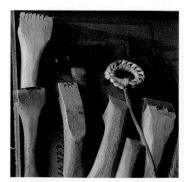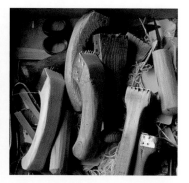

differentiate and feel what pieces are going to be good for different styles of baskets. So there's a lot to it."

Once the ash is pounded, split, and gauged, the splints are then woven around a wooden form called a block or a mold. These handmade wooden molds give the basket its size and shape. Specific blocks, some designated by size (6 1/2 inch), some by form (strawberry, acorn, corn) and some by function (laundry hamper, pack), are used to produce specific baskets. Using a technique called plaiting, the basketmaker turns up the basket's sides and follows the block's contours as he or she weaves the splints over and under.

Like other basket-making tools, blocks are kept in families to maintain certain styles and to train the next generation. Usually identifiable by carved initials, these blocks are rooted in lineage and tradition. In a world of change, these wooden forms offer a sense of continuity. Molly Neptune explains: "Basket making is a traditional art. I use the same tools that have been used throughout time. My splitting tool belonged to my grandmother. I have blocks that have been passed down."

After the development of blocks and gauges in the mid-1880s, splint baskets began to be produced in larger quantities by several Northeastern tribes including the Penobscot, Passamaquoddy, and Haudenosaunee. By using gauges, blocks, and splitters, basketmakers could also make smaller, more delicate baskets. These tools encouraged more flexibility and creativity in basket shapes and sizes. Basketmakers could create a range of different baskets from the same block. For example, an acorn block could also be used to create a strawberry basket. But although these forms helped to create a certain uniformity, no two baskets were, or are now, the same. A basketmaker's skill and creative choices greatly influence the "look" of the basket.

Judy Cole's molds and blocks, photo © Peter Dembski

Closeup of Henry Arquette's picnic basket, photo © Peter Dembski

Miniature pack basket by Harold Lafford, photo © Peter Dembski

Hamper by Donald and Mary Sanipass, photo © Peter Dembski

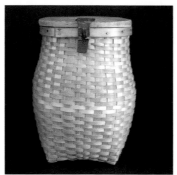

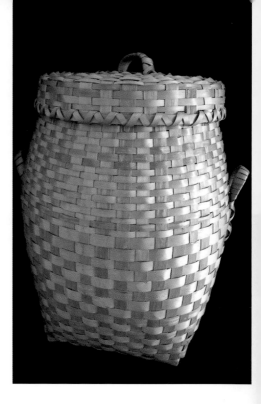

The Work Basket

Originally made for use on the farm, in the woods, or on the water, work baskets take many forms: bushel baskets, pack baskets, fishing traps, laundry hampers, picnic baskets, egg baskets, potato baskets, fishing creels, pie baskets, shoppers, knitting baskets, fish scale baskets, wedding baskets, and corn-washing baskets. Functional and durable, work baskets are traditionally made by men. With no dyes or sweetgrass used, the beauty of these baskets lies in their simple, elegant forms.

The work basket has a long utilitarian history in the Northeast. For example, up until the 1960s, potato baskets and fish scale baskets were widely used in the agricultural and fishing industries of Maine.

Fish Scale

Fish scale baskets were used in the sardine and herring factories of Washington County, Maine. The scales were collected and eventually used as an emulsifier in such things as nail polish. Molly Neptune remembers her family making "scale" baskets in Princeton. "There would be five or six families just making scale baskets. We sold our baskets to the pearl essence plant where they made fingernail polish. They were used to hold the scales from the boats or the sardine factory until they transported them to the pearl essence factory."

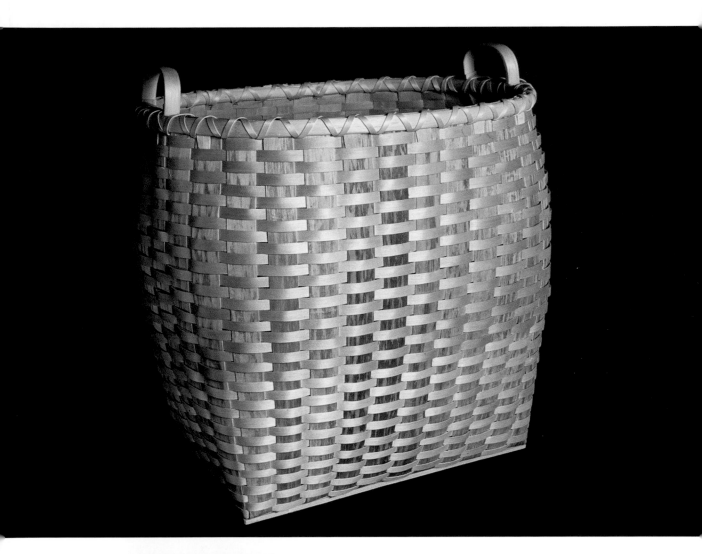

Pack basket by Henry Arquette, photo © Peggy McKenna

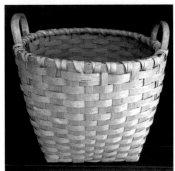

Fish scale basket by Peter Neptune (Passamaquoddy), photo © Peter Dembski

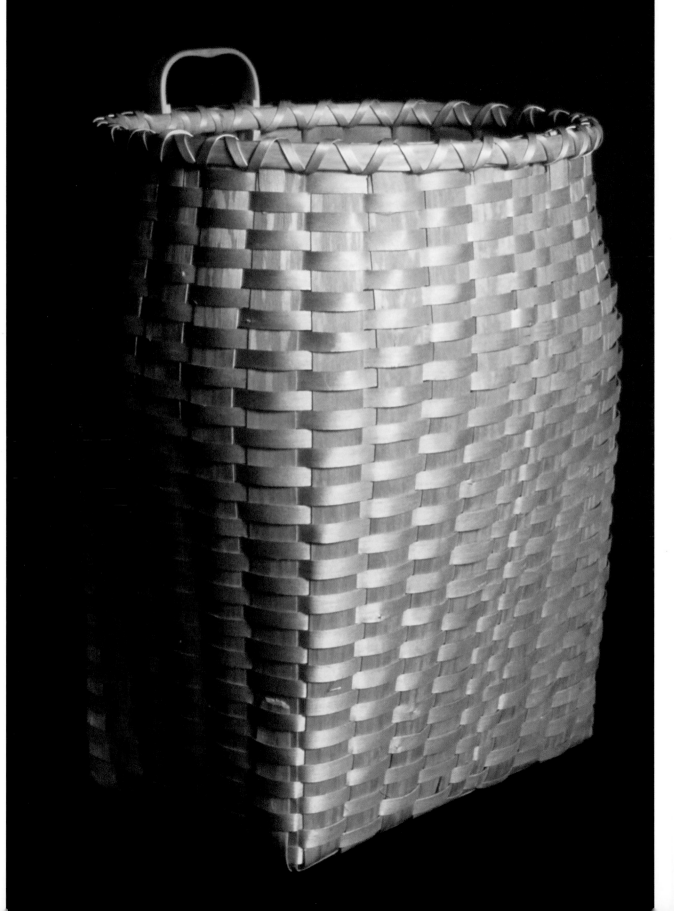

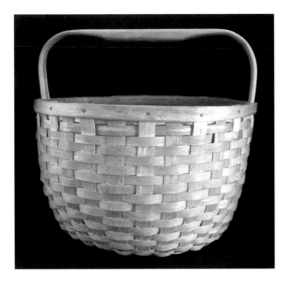

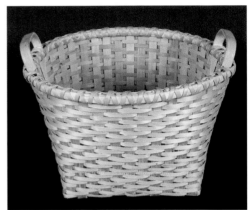

Pack Basket

Originally used for harvesting crops, the pack basket has also been used for hundreds of years to carry equipment for camping, fishing, canoeing, and hunting. Today, carrying a backpack is a common sight; its predecessor, the pack basket, was created by the Native artisans of the Northeast.

Potato Basket

Micmac and Maliseet basketmakers sold their sturdy baskets by the dozens to Aroostook County potato farmers for hand-harvesting the crop each fall. Many of the basketmakers also worked in the potato fields themselves.

Corn-Washing Basket

At Akwesasne, Mohawk basketmakers make corn-washing baskets. Used to rinse corn that has been boiled with ashes, these baskets feature a beautiful twill weave on the sides for strength. On the bottom, basketmakers create a checkered weave that allows the ashes and corn hulls to be washed away. These patterns are also used in other styles of Mohawk splint basketry.

Potato basket by the late Jim Tomah (Maliseet), photo © Peter Dembski

Corn-washing basket by Henry Arquette, photo © Peggy McKenna

Opposite page: Pack basket by Henry Arquette, photo © Peggy McKenna

For many Native people, basket making helped support their families. It was part of a seasonal cycle of jobs that might also include digging potatoes in the fall, lumbering in winter, raking blueberries in the summer, and selling baskets to farmers and tourists in the summer.

Richard Silliboy, who grew up in a basket-making family in northern Maine, remembers both hard work and hard times. "I grew up with basket making. My mother was a basketmaker who supplied a lot of the local farmers with the potato baskets that they needed to harvest their crops. Although my siblings worked for the local farmers, they also helped with the basket making in the evenings, or, if they were not employed, they helped make baskets full time. It was not unusual for my family to make a hundred to a hundred and fifty baskets a week. I remember my mother selling these baskets for fifty cents each. Although I came from a basket-making family, I wasn't interested in it because of the terrible value of baskets in Aroostook County. I saw my mother work so hard and get so little out of it, and that discouraged me."

This long association with "just getting by" had a negative impact on the future of the tradition. In Aroostook County, for example, Micmac basketmakers wanted better prices for their work, while potato farmers were looking for the least expensive way to get their crop in each fall. These two conflicting demands greatly influenced the next generation of basketmakers.

The late Maliseet work-basket maker Aubrey Tomah spent most of his life making work baskets in Aroostook County. He described the problem this way: "It's really hard to say how much time you've got into a basket, and if you charge thirty dollars for the basket, my God, they fall over. They don't realize how much time went into making that basket, so when an Indian sells a basket, he shouldn't feel bad if he gets a good price for it."

But despite the hardships, a tradition once linked with poverty is now enjoying a resurgence as a source of cultural pride, especially among young men.

Richard Silliboy pounding ash, photo © Jere DeWaters

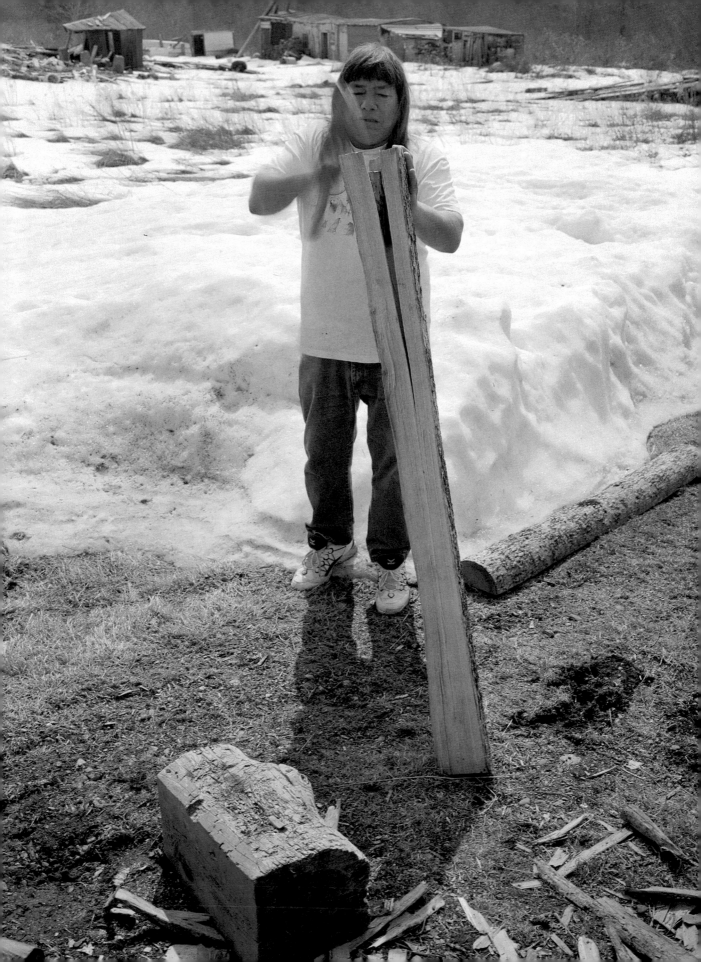

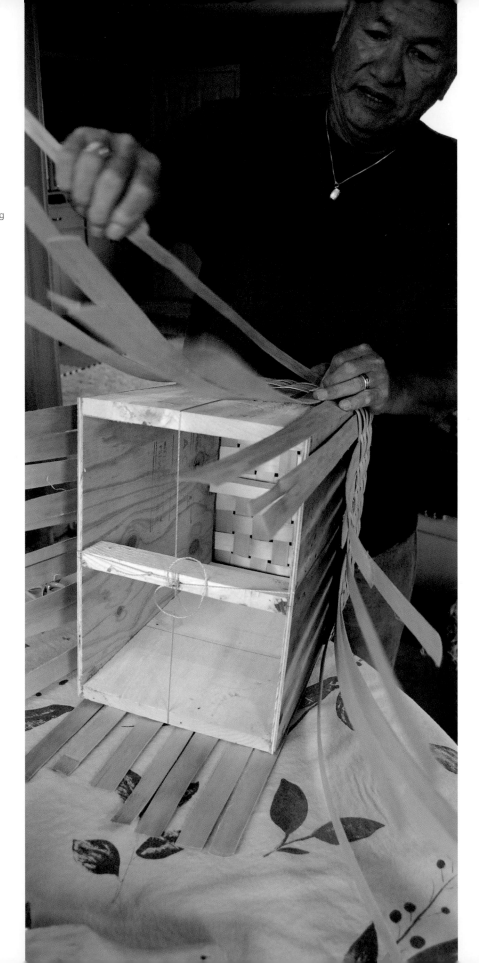

Richard David weaving
utility basket, photo
© Peter Dembski

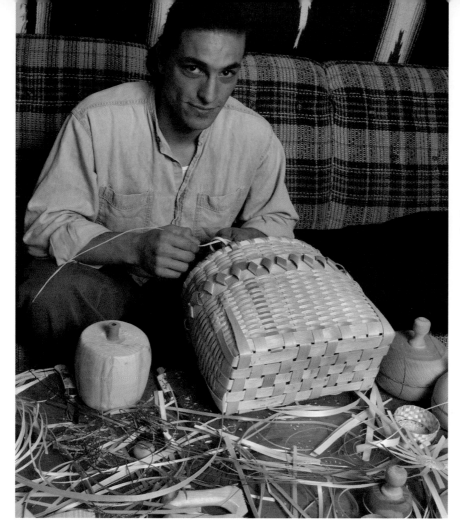

Gabriel Frey, photo
© Peggy McKenna

Gabriel Frey, Passamaquoddy

"I have always lived among basketmakers. For as long as I can remember, basketry has been a part of my life. For generations, my family has made a living creating and selling Native baskets. My grandfather has been my mentor in relation to my basket-making skills. It is because of the teachings I gathered from him that I am able to make utility baskets that are both strong and beautiful. When I made my first basket, my grandfather was beginning to age rapidly and no one else was picking up his craft. Several members of my family had picked up the art of making fancy baskets and doing beadwork, but no one was taking on the art of utility-basket making. To me it felt like a necessity to learn this craft before it was lost forever. In doing so, I hope to continue the utility-basket lineage that my grandfather and I are both a part of, so that it will someday be able to thrive as the fancy-basket art is now thriving."

THE FANCY BASKET

The end of of the nineteenth century marked the emergence of the tourist industry in the Northeast. City dwellers flocked to places like Niagara Falls, Saratoga Springs, the Adriondacks, and Bar Harbor for relaxation and to enjoy the beauty of nature. After their summer respite, many would return home with a memento, usually made by Haudenosaunee or Wabanaki artisans. Responding to this new market, Native craftspeople fashioned traditional materials like ash, sweetgrass, birchbark, root clubs, and beads into a range of work for sale.

Basketmakers in particular expanded their repertoire of making functional work baskets into more "fancy," decorative collectibles. Using their imagination and creative abilities, basketmakers could fashion ash into just about anything: wastebaskets, wall pockets, planters, napkin rings, button boxes, sewing baskets, handkerchief boxes, thimbles, glove boxes, scissors cases, collar boxes, fishing creels, pie baskets, and picnic baskets.

"Penobscots made everything from birds and flowers to a million types of baskets. Everyone was his or her own artist. Whatever was in their mind, whatever they wanted to make, they could create it." —Christine Nicholas, Penobscot basketmaker

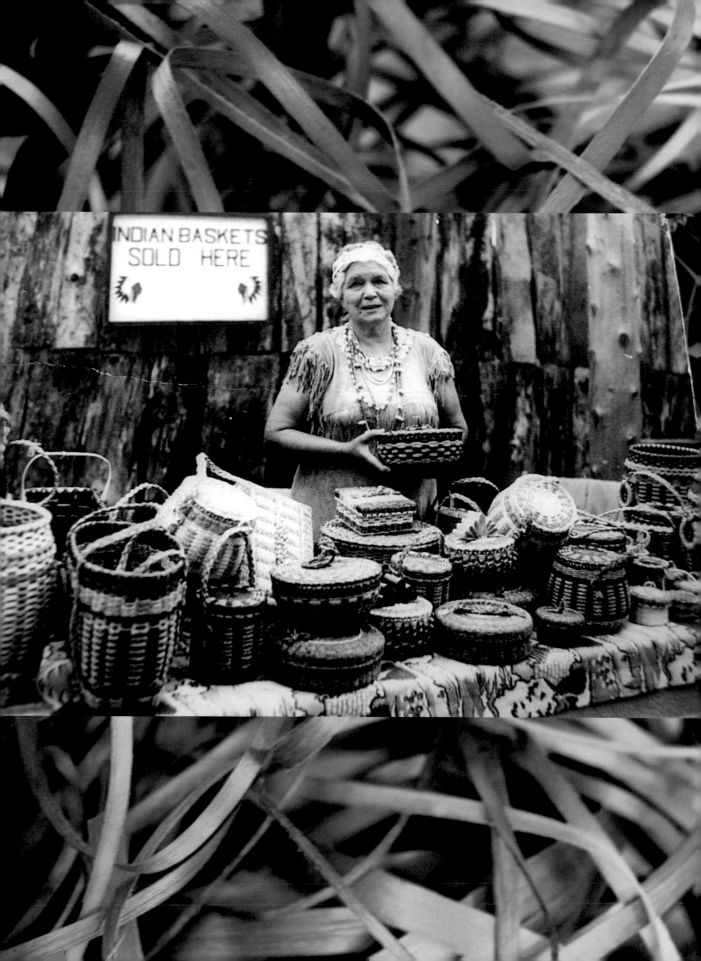

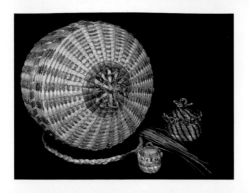

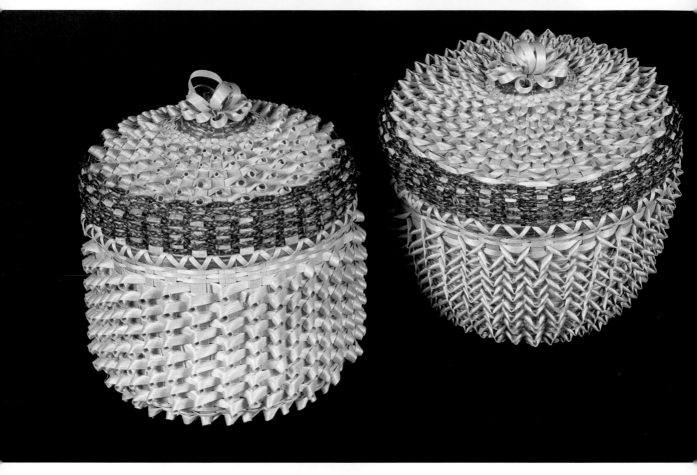

Basket by Connie Sunday (Mohawk),
photo © Peggy McKenna

Strawberry basket by Denise Jock (Mohawk),
photo © Peggy McKenna

Popcorn-weave baskets by Linda Jackson (Mohawk),
photo © Peggy McKenna

Collection of baskets by Barbara Gray (Mohawk),
photo © Peggy McKenna

In developing creative solutions for economic survival, these artisans also helped establish a market for handcrafts in the Northeast. "Objects were made not only by Iroquois, but also by Micmac, Maliseet, Huron, and Abenaki people living from maritime Canada to western New York State. They were circulated throughout a wide area by efficient intertribal trading networks that had been in existence for many centuries. These networks also ensured that new artistic ideas spread quickly throughout the Northeast, bringing about an overall similarity of object types in the region." (Phillips, p. 26.)

Native American families prepared for the summer market by working all winter long. Madeline Shay remembers selling baskets with her family in both Maine and New Hampshire. "I've made baskets since as far back as I can remember. My grandmother always had a shop. We went to Rye Beach, New Hampshire. She had a tent there and then we moved to Poland Springs and that's where I was born. We were there for twenty years or more—every summer, right across the road from where they bottled all the water, we would sell baskets."

Eastern Woodlands people have always been attuned to the marketplace. In the nineteenth century, aware of the Victorian fondness for ornamentation, basketmakers adorned their baskets with brightly colored splints, inventing a wide range of weaves and twists that were embellished with sweetgrass. Beadworkers invented "raised beadwork," elaborately crafted layers of beads on velvet.

Basketmakers also began using commercial dyes for splints. Today, many basketmakers continue to use dyes, weaving brightly colored ash splints that are all one color, or alternating natural splints and colored ones.

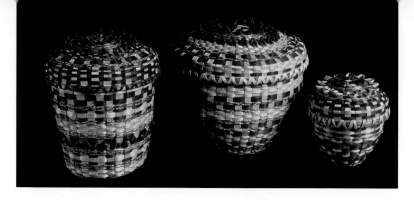

Basket by Theresa Angus, photo © Peggy McKenna

Theresa Angus, Mohawk/Snipe Clan

Theresa Angus of Akwesasne loves making baskets. "I could do it all day," she says. Her grandson usually wakes her up in the morning and she starts making baskets "till suppertime." When Theresa Angus was growing up at Akwesasne, she helped her mother, Josephine Angus, split and scrape the pliable black ash into thin strips for weaving. Sometimes she made colorful bookmarks out of the leftover splints. She also picked sweetgrass with her mother and learned how to prepare and braid the fragrant material for weaving.

Today, she is an accomplished basketmaker making a variety of beautiful fancy baskets from 3 to 6 inches, using a number of traditional Mohawk weaves like thistle, pineapple, and popcorn in a range of colors from purple and burgundy to green.

Clara Keezer, Passamaquoddy

Clara Keezer started making baskets when she was eight, in the Passamaquoddy community at Pleasant Point. "I built a basket around a glass jar to make as a vase and sold it the next day for fifty cents. In 1938 that was a fortune! I enjoyed the work and took it up to make some pocket money. Very soon, I had regular clients and it's been that way for as long as I can remember."

Her parents and grandparents were prolific and accomplished basketmakers who supported their families by selling their work. Raised by her grandparents, Clara Keezer grew up around basket making. Her grandmother, Elizabeth, a Penobscot, was known for her work baskets.

A master fancy-basket maker, Clara has been making baskets for over sixty years. She loves basketmaking. "Sometimes, I can't wait to get up in the morning just to start making baskets again." The National Endowment for the Arts awarded Clara Keezer a National Heritage Fellowship in 2003.

Clara Keezer holding
blueberry baskets,
photo by Cedric N.
Chatterley

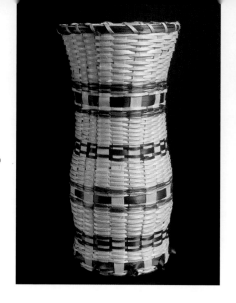

Vase by Vicky Phillips,
photo © Peggy
McKenna

Sheila Ransom, photo ©
Peggy McKenna

Vicky Phillips, Mohawk/Wolf Clan

Vicky Phillips grew up at Akwesasne and learned basket making from her mother-in-law, Agnes Phillips, and master basketmaker Mary Adams. She went on to take basket-making classes at the Akwesasne Museum, where she learned the entire basket-making process "from tree to finished basket."

Known for her creativity and use of colors, Vicky makes many traditional baskets like her miniature strawberry baskets, but she also likes to experiment with different shapes, especially baskets woven around glass containers. "You give me a jar and I'll weave it," she says.

Sheila Kanieson Ransom, Mohawk/Wolf Clan

Sheila Ransom, a grandmother of four, has been making baskets for more than ten years. She first learned from the renowned Mohawk basketmaker, Mae Bigtree, her godmother and first cousin. Mae was a strict teacher, telling Sheila, "*Saeserishi* [Mohawk, meaning take it back off] and start the basket over again." Sheila later studied with Henry Arquette, learning how to make picnic, laundry, and corn-washing baskets. An antique basket mold inspired her to make a sewing basket that won first prize at the 2005 New York State Fair.

Basket making has become a passion for Sheila Ransom. Her two granddaughters like to keep her company as she works, and she dreams of the day when she can begin to teach them. But for the immediate future, Sheila plans to continue to work with elders to learn different basket-making techniques.

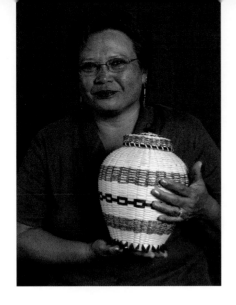

Debbie Cook-Jacobs (Kanerahtiiohsta), Mohawk/Bear Clan

For Debbie Cook-Jacobs, a basket represents the past, present, and future, keeping her connected to the earth by finding, preparing, and using natural materials. She has been making utility and fancy baskets for the last twenty years and knows the entire process "from tree to basket." She credits Salli Benedict and the Akwesasne Museum, where she was taught by a number of Akwesasne basketmakers, for instilling an appreciation of basket making.

Robin Lazore, Mohawk

Robin Lazore, a Mohawk from Akwesasne, has been weaving baskets for over twenty years. She is known for her strawberry and pineapple twist baskets. Robin began weaving in her teens, learning from elders like Mary Jocko and Irene McDonald. When Mary Jocko retired, she passed on some handmade basket blocks to Robin. Irene McDonald shared her skills and became an inspiration, always challenging Robin and giving her the confidence to try more difficult baskets.

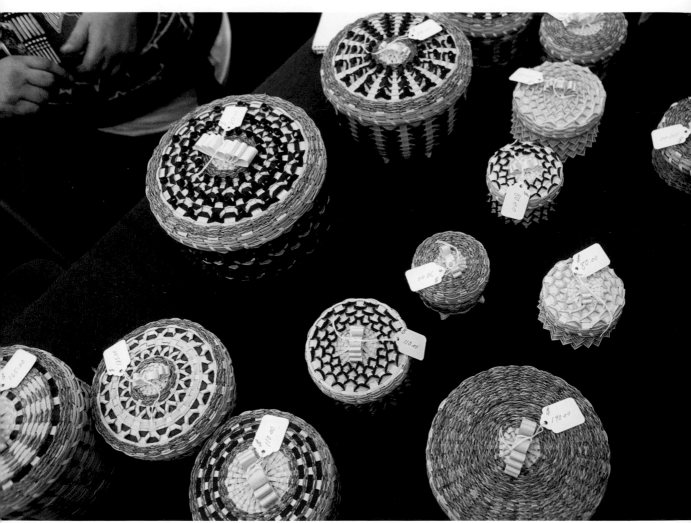

Baskets for sale at the Common Ground Fair, Maine, photo by Cedric N. Chatterley

Detail of basket by the late Mary Gabriel (Passamaquoddy), photo © Peter Dembski
Detail of Jeremy Frey basket (Passamaquoddy), photo © Peter Dembski

The tourist market influenced styles in basket making and beadwork in the Northeast. The extraordinary range of color, ornamentation, and innovation continues today. Scholar Ruth Phillips suggests that the development of "tourist" art helped establish a long-standing relationship between Native craftspeople and non-Native consumers, one that influenced artistic decisions and found new functions for old forms. The rugged work basket now holds magazines and the beaded bag, a cell phone. (Nicks, p. 302.)

Emergent and ever-changing, Wabanaki and Haudenosaunee craftspeople continue to respond to the demands of the marketplace. Some sell at craft festivals, others through cooperatives, and some on websites, in galleries, and through Native-run ventures like the Wabanaki Arts Center Gallery in Old Town, Maine, or at powwows. The challenge for these contemporary craftsmen is to find new markets and to get equitable prices for their work.

As Passamaquoddy basketmaker Jeremy Frey explains: "Creating the level of basketry that I envision requires a significant time commitment, and this investment requires a sale price to match the amount of time, materials, and creative intelligence that's been invested in it. In order for basketmakers to continue to improve their art form, the market will also have to be

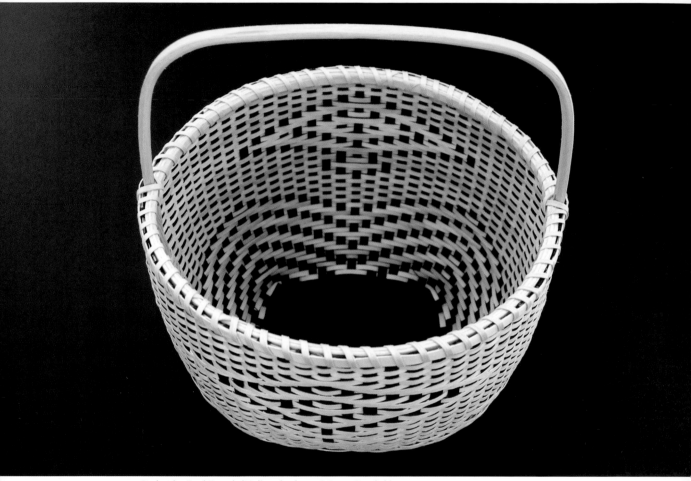

Basket by Fred Tomah (Maliseet), photo © Peter Dembski

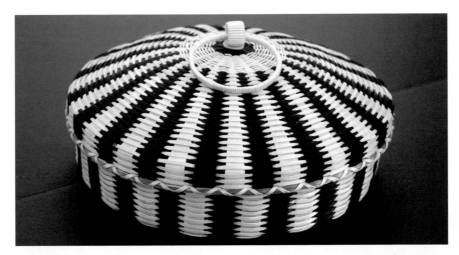

Basket by Jeremy Frey (Passamaquoddy), photo © Peter Dembski

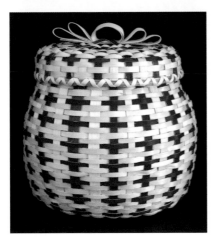
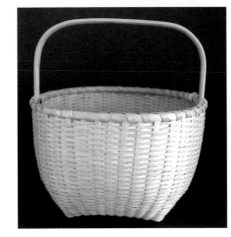

Basket by Max Romero (Micmac), photo © Peter Dembski

Basket by Fred Tomah (Maliseet), photo © Peter Dembski

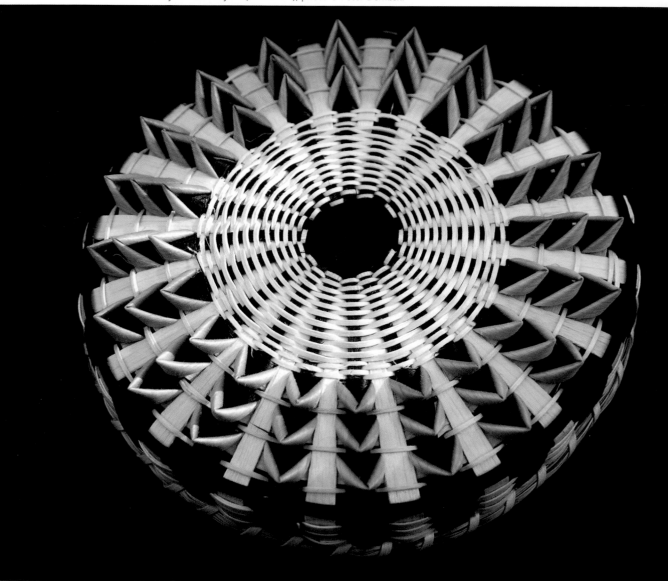

Basket by Ganessa Bryant (Penobscot), photo © Peter Dembski

Basket by Kim Bryant (Penobscot), photo © Peter Dembski

Basket by Molly Neptune (Passamaquoddy), photo © Peter Dembski

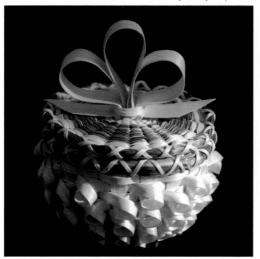 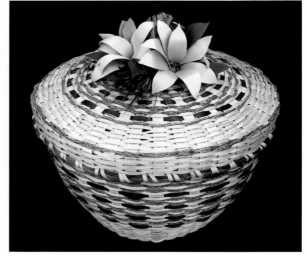

revitalized to support the increase in quality, otherwise no one will be able to earn a living as a Native weaver."

For many of the artists, making and selling their work affords a measure of economic independence. Beadworkers, in particular, often sell their work to other tribal members interested in ordering custom work. Tuscarora beadworker Marlene Printup notes, "My grandmother and my husband's grandmother always said, 'You'll never be broke. You've always got your beadwork. There's always somebody looking for something.' It seems like that's quite true. Sometimes, you need a little bit of money and lo and behold, somebody comes along looking for something." (Knapp, p. 20.)

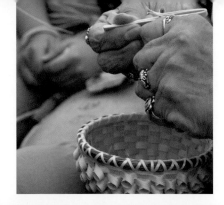

Basket by Caron Shay, photo © Peter Dembski

Caron Shay with granddaughter and her father, the late Billy Shay, photo by Cedric N. Chatterley

Basket by Caron Shay, photo © Peter Dembski

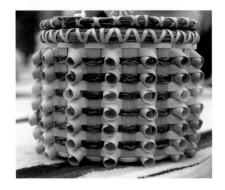

Caron Shay, Penobscot

"My grandmother told me, 'Here's the material, here's the gauges, here's the knife. Learn how. It will come in handy for you when you grow up and have a family—you watch and see.' I found out, when the kids wanted piano lessons, baskets paid the bills and brought us food," said the late Madeline Shay to her daughter Caron.

Caron Shay, now a master Penobscot basketmaker in her own right, continues her family tradition and is teaching her grandchildren. "I think basket making is going to make a comeback because of the prices. The prices of baskets are going so high that the kids are getting interested in it. It's an incentive for them to learn something that will be carried on down through the generations, and hopefully, when they do finally grow up, they will teach the next generation coming up behind them. Each generation that comes along behind the rest will learn, even if it's for the monetary value— but at least that way something isn't going to be lost, another part of our tradition is not going to be lost."

A member of the Board of the Maine Indian Basketmakers Alliance, Caron Shay is one of a group of basketmakers working to preserve the traditions and styles of Penobscot basket making. She specializes in Penobscot classics like the curly bowl, button box, and acorn.

Always adapting to changing cultural and economic conditions, these artists have successfully managed to maintain their cultural identity while continuing their entrepreneurial ways in some of the most remote regions of the Northeast, just like their ancestors.

As Salli Benedict suggests, "Freed from financial dependence on basketry as a livelihood and from the necessity of meeting the inflexible demands of wholesale basket merchants, basketry as a whole has taken on a

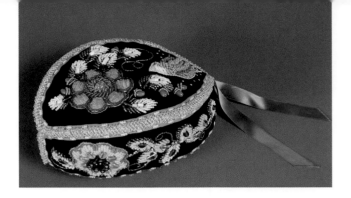

Akwesasne Mohawk
gustoweh, courtesy of
Akwesasne Museum,
photo © Peggy
McKenna

Glengarry hat by
Rosemary Rickard Hill
(Tuscarora), photo
© Peggy McKenna

Beaded boot by Niio
Perkins, photo by Roger
Harmon

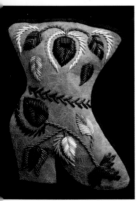

special individuality as a result of the personal freedom and growth of each artist. In this sense, basket making has been elevated to a refined art by people who enjoy creating for themselves endlessly innovative designs—all still based on the use of traditional materials, methods, and styles." (Benedict, p. 10.)

The Glengarry Hat

Innovation is evident in the making of beaded hats by Tuscarora and Mohawk beadworkers. Made of cotton-lined velveteen and beautifully beaded, the "Glengarry Hat" was in great demand during the Victorian era. These hats are still made by Tuscarora beadworkers. The word *Glengarry* references their similarity to Scottish military headgear, but Tom Hill suggests that they are closer in form to Haudeonsaunee *gustoweh*. (Hill, p. 68.) A symbol of Haudenosaunee identity and belief, the gustoweh is worn by men at longhouse ceremonies and important occasions.

Beadworkers have always referenced ancient designs in creating beautiful hats, moccasins, bags, and jewelry. Centuries ago, shells and porcupine quills were an essential part of the cultural traditions of the Haudenosaunee and the Wabanaki. After European contact, glass beads replaced these materials and were integrated into beading traditions.

During the nineteenth century, Haudenosaunee artists began creating raised beadwork. Layered, textured, and brightly colored, this beading technique blended traditional designs with the Victorian penchant for ornamentation. Sold to tourists visiting Niagara Falls, Saratoga, and Montreal, three-dimensional beadwork was applied to velvet in a variety of forms ranging from pincushions, picture frames, wall pockets, and table coverings to purses, hats, and even boots.

As these souvenirs grew in popularity, beadwork became a dependable source of income for many families, especially the Tuscarora. Tuscarora women have sold their work at Prospect Point at Niagara Falls for generations, and many skilled beadworkers still live on the Tuscarora Reservation, located on 5,000 acres near Niagara Falls.

Dolly Printup Winden wearing Glengarry hat, photo © Peggy McKenna

Jennifer Neptune sewing beads, photo © Peter Dembski

Back of Glengarry hat by Dolly Printup Winden, photo © Peggy McKenna

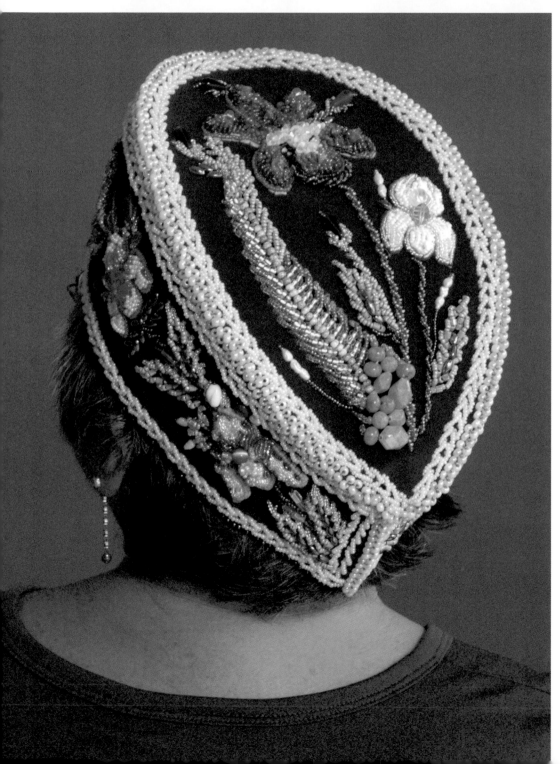

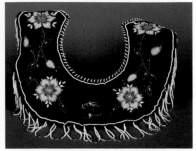

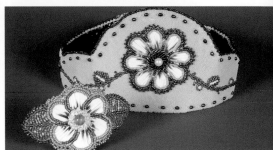

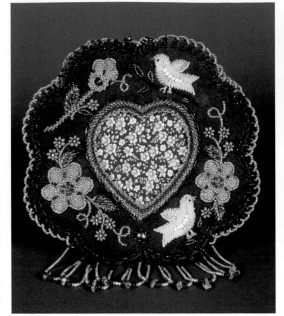

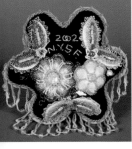

MORE BEADWORK

"Tuscaroras are noted for raised beadwork and flowers. From different areas, you can tell the different types of work. From here, we see somebody's work, we can almost pick out whose work it is. Individuals have their own styles," explains Tuscarora beadworker Marlene Printup. A gifted artist, Marlene has also taught her daughter, Mary Annette Clause, how to bead:

"Raised beadwork looks like the beads are raised up and appears to be three-dimensional. There may or may not be a row of beads underneath, depending on the type of raised work you are doing. I draw a circle to start the center of the flower. Then I take the beads and leave a little space in between, just enough for two rows of beads to come up. I keep working on a slant so it will help raise up the other beads. For petals, I put a row of beads underneath for the first row. You just put a little bit more beads than what the actual pattern calls for and it will raise the second row of beads. It's the overlapping of the beads on top of each other that gives it the raised look." (Knapp, p. 21.)

Tuscarora beaders continue to create work for personal use, for community gatherings, and for extra income. Given as gifts at births, weddings, and anniversaries, beadwork plays an important part in contemporary Haudenosaunee spiritual and social traditions. Like their ancestors, the Haudenosaunee still wear beaded clothing at longhouse ceremonies, important gatherings, and community events.

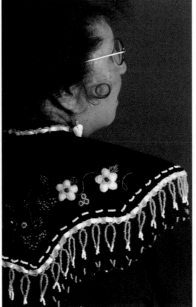

Traditionally, beadwork—especially collars, crowns, and cuffs—reflects the wearer's personal aesthetic, as well as his or her relationship to the spirit world. For many, it is a personal as well as community-based expression of being Haudenosaunee.

"Beadwork tells a story," explains Marlene Printup. "We put to work our love for flowers and birds in our own way on velvets. Different areas have their own styles of beadwork. Out West, they use little tiny beads. Their patterns are geometric with very little floral design, whereas the Iroquois [Haudenosaunee] on the East Coast have floral designs and birds, leaves, and trees, rivers and waters. The domes on the beadwork represent the skies, and the swirls, the waters. The scallops are domes for the sky; the roundness and circles are for the sun and the moon. The leaves and trees and flowers and birds are things that we cherish." (Knapp, p. 20.)

Because beadwork is the embodiment of a living cultural heritage, it is the practicing artist who brings this legacy to life, making it meaningful to present and future generations. Often recognized as the ones who are "doing it right," traditional beaders are highly respected by fellow community members. Through their work, they put in motion a sometimes unspoken conversation about the maker's creativity and the community's sense of what is beautiful and true.

Beaded collar worn by Dorene Rickard, photo © Peggy McKenna

Back of beaded collar by Dorene Rickard (Tuscarora), photo © Peggy McKenna

Beaded collar by Mary Annette Clause (Tuscarora), photo © Peggy McKenna

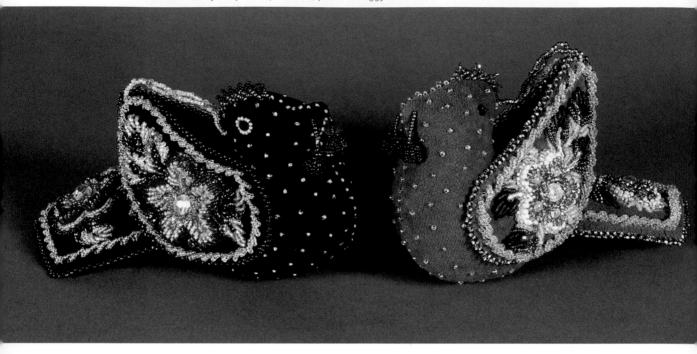

"I have patterns from my grandmother that I use for some of my beadwork designs. She always said she never had a pattern. She would draw a circle first and then by tracing her little finger or her pointer finger, go around the outside of the circle. That's how she would make her flower pattern. She said, 'Nothing's perfect. We're not perfect. And don't try to be perfect, either. There's always a mistake in everything we do!' If I make a mistake, I just leave it because she said that's the way life is. People make mistakes. You just keep going with what you're doing." —Mary Annette Clause (Knapp, p. 23.)

Dolly Printup Winden, *Tuscarora*

Dolly Printup Winden remembers her Tuscarora grandmother Matilda Chew Hill, as a patient teacher. A recognized beadworker, Matilda Chew Hill helped organize the Tuscarora community into a beadwork "cottage industry" at Prospect Point in Niagara Falls.

Her grandmother's life and work continue to inspire Dolly Printup Winden. Much of what Dolly's grandmother taught her about beadwork is connected to traditional spiritual beliefs. "My grandmother was a very spiritual person," Dolly recalls. "She would say that when you sew you are bringing your blessings back to you

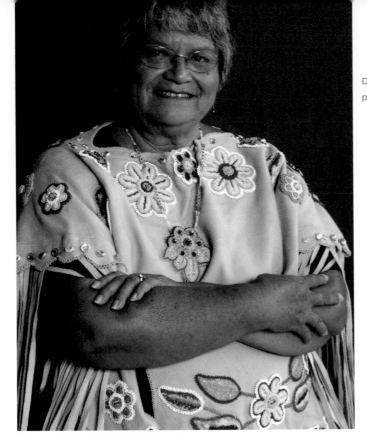

Dolly Printup Winden,
photo © Peggy McKenna

because you push your needle up and then bring it down to you, like your blessings."

Known for her decorative beaded birds, Matilda Chew Hill explained their meaning to Dolly: "The Creator made birds for us to enjoy, but in the spring, the birds are supposed to sing and wake up the flowers and nature. I am helping spring come back by sewing."

Beadwork sustains and renews ties to family, place, and tribe. Practicing a traditional art is a way of being Wabanaki or Haudensosaunee. "We just have to work together to get that beadwork idea out, that we still make raised beadwork just like my ancestors did. We are letting them know that the Indian people are still doing beadwork," Dolly explains.

But these traditions are not just passed along unchanged. As they come into the hands of the next generation, they are transformed. Beadwork and basket making are continually being reinvented. As Sue Ellen Herne suggests, "We cherish the connection to our ancestors and embrace the creativity that adds new ideas to our long-standing art forms. Each basketmaker, each beadworker, also brings a personal touch and signature style to the tradition."

95

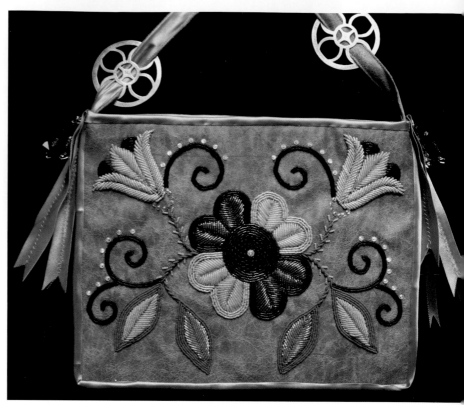

Niio Perkins wearing beaded collar, photo by Roger Harmon

Beaded bag by Niio Perkins, photo by Roger Harmon

Niioieren "Niio" Perkins, Mohawk

Niio Perkins, a twenty-seven-year-old Mohawk Bear Clan artist and beadworker, grew up at Akwesasne. *Niioieren* is Mohawk meaning "look what she did." Her mother sews traditional Mohawk ribbon shirts and dresses for ceremonies, dance competitions, and weddings. Inspired by her mother, Niio began beading earrings and other jewelry at an early age.

Niio Perkins's beautiful beadwork incorporates many older Haudenosaunee designs such as strawberries, fiddleheads, and hummingbirds—all symbols of one's relationship with nature. Contemporizing these traditional designs, Niio uses very small beads to create beautifully rich colors, as well as sheen and texture.

Niio Perkins tells us that "trading is deeply rooted in Mohawk culture, and many Native artists will trade work with each other because they believe that there is more significance in something that has been individually crafted from one's hands. No dollar can match the time, thought, and love that goes into each creative art form."

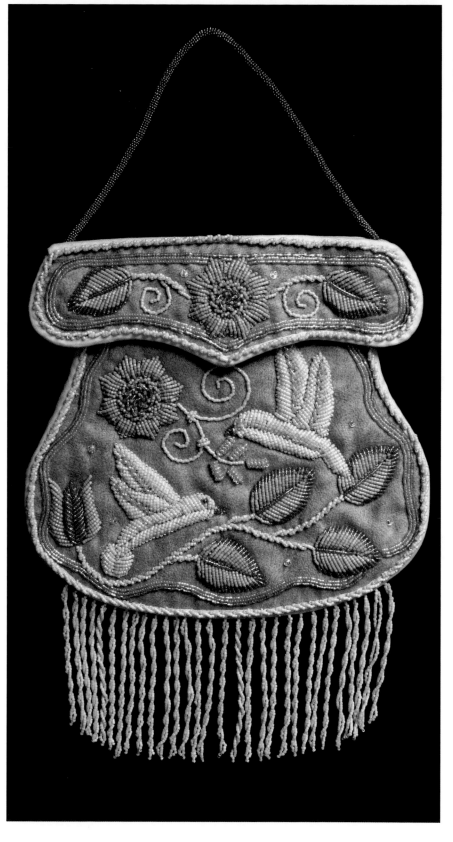

Beaded bag by Niio
Perkins, photo by Roger
Harmon

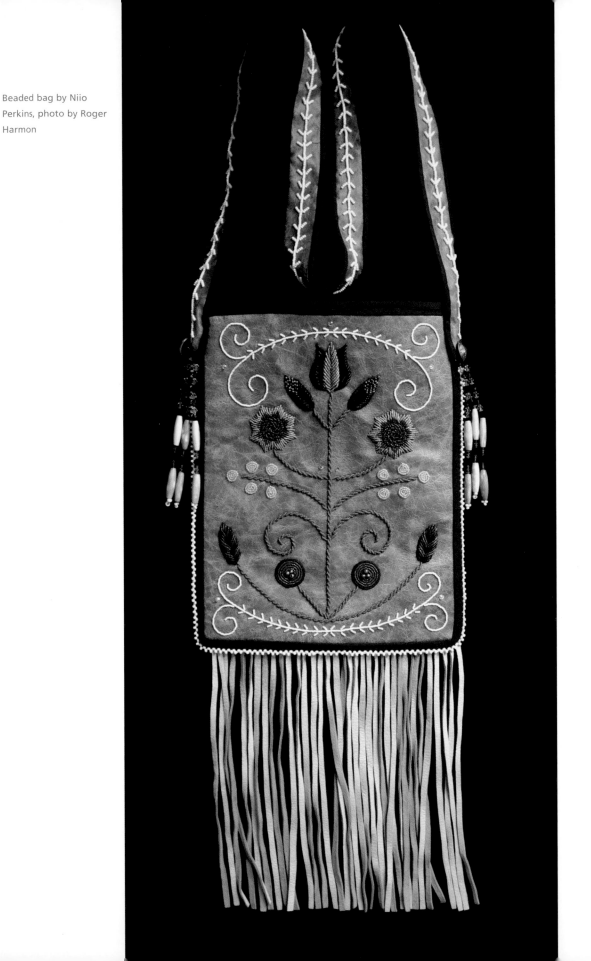

Beaded bag by Niio Perkins, photo by Roger Harmon

Details of Niio Perkins's work, photo by Roger Harmon

Niio Perkins beading, photo by Roger Harmon

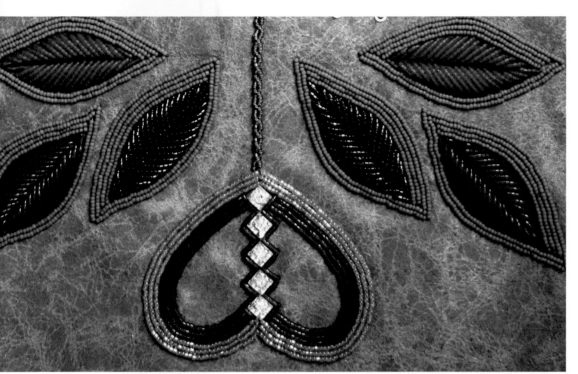

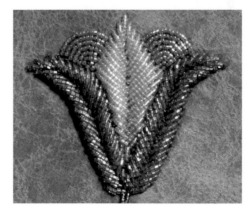

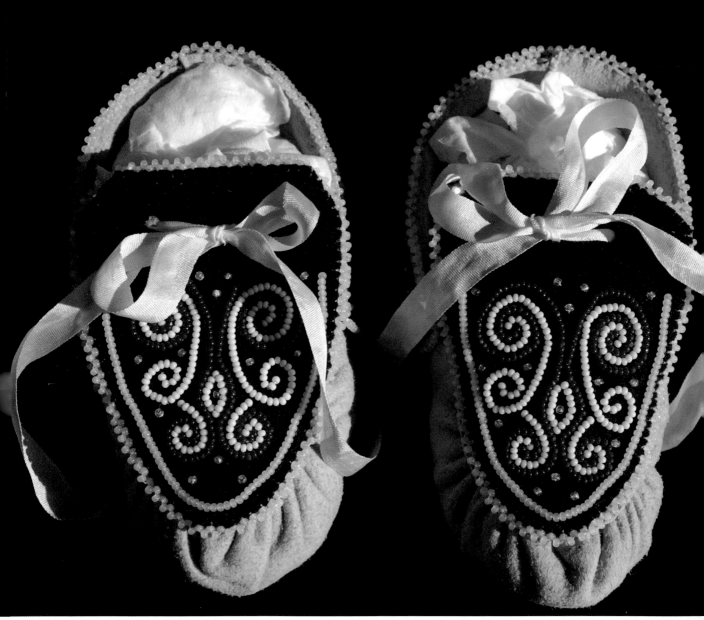

Beaded moccasins by Jennifer Neptune, photo © Peter Dembski

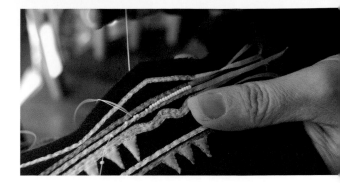

Jennifer Neptune, Penobscot

Jennifer Neptune is a talented Penobscot beader and basketmaker living on Indian Island, Maine. Growing up, she often visited her grandmother, a painter who had a studio in nearby Old Town. Such visits fostered an early love for art and color. Jennifer's passion for traditional arts began over twenty years ago, at age sixteen, when she first got interested in northeastern beadwork traditions. Soon after, she began making jewelry and selling her work at powwows across the country.

An accomplished basketmaker as well, Jennifer Neptune helped establish the Wabanaki Arts Center Gallery in Old Town, and is currently the manager of the Maine Indian Basketmakers Alliance. In 2006, Penobscot elder Charles Shay commissioned Jennifer to make a beaded ceremonial chief's collar in honor of his mother, Florence Nicolar Shay. A Penobscot basketmaker, Florence Shay was a respected cultural advocate and teacher.

Using an old photograph of Florence wearing a beaded collar, Jennifer Neptune began her research at the Smithsonian's Museum of the American Indian. While visiting the museum, she also looked at other examples of Wabanaki beadwork and ribbon work. During the latter part of the eighteenth century, ribbons began to appear on the clothing of the Haudenosaunee and the Wabanaki. Ribbon work was applied as borders or as background for the white beads that decorated clothing.

In her work, Jennifer Neptune references the double-curve motif of the Wabanaki, which traditionally symbolized the unity of the tribes of Maine. Jennifer explains that the "double-curve designs were transformed into brilliantly colored floral designs inspired by medicinal plants and flowers, and are closely intertwined with Wabanaki culture as a whole."

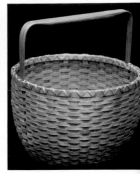

PASSING IT ON

"There is so much a person could say about basket making. The past, the present, and the future, all are so important. But there is nothing more important than being willing to help keep this tradition alive and to teach as many Native youth as we can how to process the brown ash tree and how to make the many different styles of baskets. It is so important to get the youth of today excited about the tradition of basket making and to teach them the history of basket making." —Richard Silliboy

A beaded collar, a quilt, a canoe, a basket; this work is a visual reminder of one's connection to past and future generations. Crafted, shaped, and treasured over time, the work holds great meaning in the everyday lives of individuals and communities.

While individually created, these arts are traditionally learned and community shared. Passed down from one generation to the next, traditional arts are usually learned in an informal way, by observation and example. Such artistic expression reflects a group's cultural values and is rooted in a shared way of life. As Eldon Hanning describes it, "There are people I teach and I don't even think about teaching because the majority of what I do is 'Watch me, watch what I do and you'll learn.' That's the way I feel. I can talk all day, but it's not the same."

The traditional way is simply "hanging out," watching and spending time with a relative or an elder who knows the techniques and the history. This give and take is a patterned exchange.

Twenty-year-old George Neptune started making baskets when he was four with his grandmother, Molly Neptune, in Princeton, Maine. "I just remember being here all the time with my grandmother," he recalls."I used to come over for a night every week. I had a special night that I would come to her house and after supper, she would weave baskets. Eventually, I just decided that I wanted to make them, too."

Molly Neptune with George Neptune making baskets, photo © Peter Dembski

Egg basket by Barbara Francis, photo courtesy of Barbara Francis

Opposite page: Theresa Secord (foreground) making baskets with Jennifer Neptune, photo by Cedric N. Chatterley

Judy Cole, photo © Peggy McKenna

In quilting, sewing, and beadwork, the next generation learns by example. At Akwesasne and Tuscarora, many basketmakers and beadworkers are also accomplished seamstresses and quilters. These skills are passed down through families, as well.

As dedicated teachers, grandparents, cultural advocates, business folks, family and community historians, these artists connect to their families and their communities in multiple ways. Such relationships are at the center of their work.

Judy Cole (Sateioianere), Mohawk/Bear Clan

Judy Hemlock Cole has "always been in baskets." Both her grandmother and great-grandmother were accomplished fancy- and utility-basket makers. As a child, she remembers going to "basket bees" with her grandmother and watching women make baskets and share work. She also went to quilting bees with her grandmother and credits her with her love of both basketry and sewing.

"My grandmother quilted a certain time of the year," Judy says. "She got old clothes, cut them up, and quilted. I remember quilting bees as a child—my grandmother always took me everywhere. All the ladies would be sitting around the quilting frame and they would get us kids to thread the needles. We would thread the needle and put it near them. We played under the quilt frame. It was like a tent to us."

Judy Cole runs the Akwesasne Quilt Club and is a member of the Akwesasne Mohawk Singers. Like her basket making and quilting, singing Mohawk songs helps strengthen her community. "We always talk Mohawk. People my age and older, we speak Mohawk. Most of our quilters speak Mohawk. We hand sew everything. I was always a community person. If you are going to join something you need to be there."

Judy Cole with quilt, photo © Peter Dembski

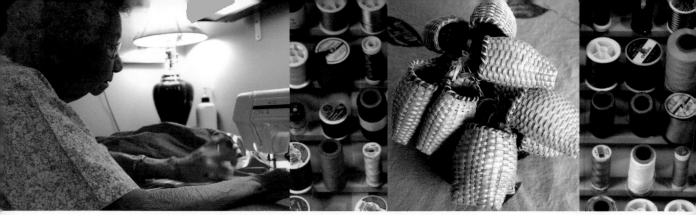

Lenora David sewing
ribbon skirt, photo
© Peter Dembski

Miniature pack baskets
by Lenora David, photo
© Peter Dembski

Lenora David (Waben,) Micmac/Eel Clan

Lenora David began life in New Brunswick, Canada, in log cabins
built by her dad along the Ontario railroad lines. Her father worked
full time cutting firewood for steam engines but somehow found
time to make ash hampers and laundry baskets. Lenora's mother also
made baskets. When Lenora was a young girl, her father was taken
by the Royal Canadian Mounted Police and never seen again. Her
mother was forced to make a new life and Lenora was sent to
Cornwall, Ontario, to be raised in an orphanage. Later, she moved to
Akwesasne, married a Mohawk man, and raised thirteen children,
making sure that all of them learned about basket making and sewing.

For many years, Lenora David worked at the Levi Strauss
factory in Cornwall, sewing back pockets for bluejeans. She remains
an accomplished seamstress, making outfits—including ribbon
shirts—for all her children and fifty-two grandchildren. She also
specializes in making miniature baskets, thimbles, and lacrosse
sticks.

Annabelle Oakes (Iawenhakie) Mohawk/Wolf Clan

While growing up at Akwesasne, instead of going out to play,
Annabelle Oakes remembers staying in and helping her grandmother
make baskets. "I just stuck with it," she says. Her well-crafted baskets
include melon baskets, knitting baskets, and sewing baskets with lots
of sweetgrass. Like many other basketmakers at Akwesasne,
Annabelle Oakes is also a quilter and has made many quilts, which
she gives to family and friends.

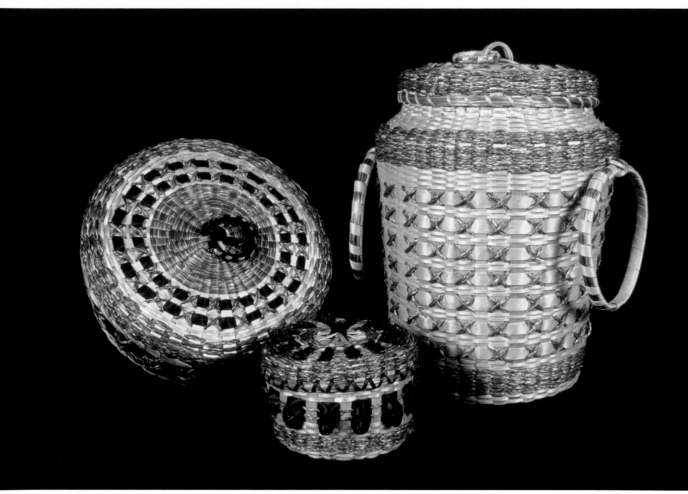

Baskets by Annabelle Oakes, photo © Peggy McKenna

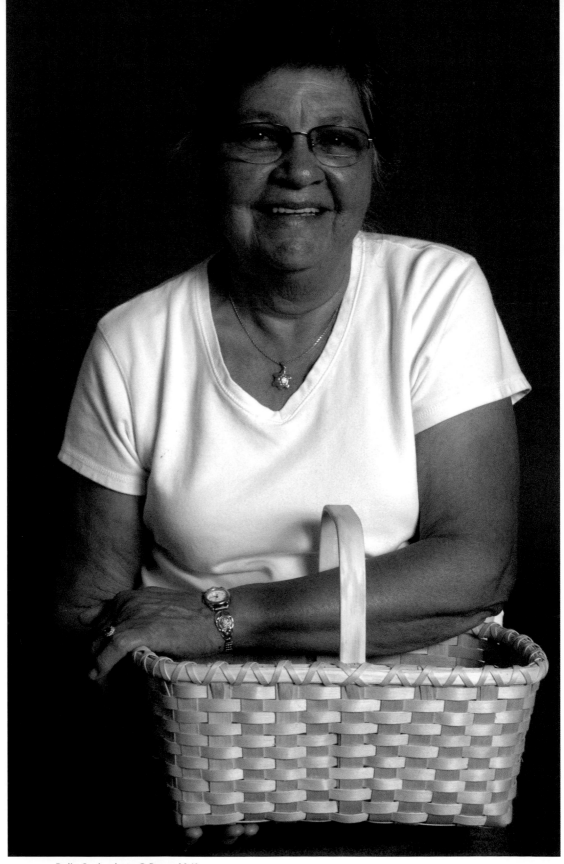

Delia Cook, photo © Peggy McKenna

108

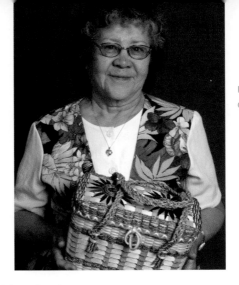

Florence David, photo
© Peggy McKenna

Delia Cook (Karihwaienhne) Mohawk/Turtle Clan

Delia Cook remembers helping her mother with "starters"—thimble cases, sewing kits, scissors cases, and pincushions—when she was eight. Over the years, she also learned from Sarah Lazore, Mary Adams, Mary Leaf, and Mae Bigtree. Since then, Delia has made many different types of utility and fancy baskets, including traditional corn-washing baskets. A talented quilter, Delia also sews ribbon shirts and leatherwork, including moccasins.

Delia Cook is a dedicated teacher, teaching basket making to younger people. She is a recent recipient of the Community Spirit Award given by First Peoples Fund. Her motto is: "Whatever you start, you have to finish."

Florence David (Kaheriiostaha) Mohawk/Wolf Clan

Florence David grew up at Akwesasne with basketmakers "all around her." She learned from her mother, Eva Point, and her aunt, Mary Adams. Her grandmother was also a talented basketmaker. Carrying on the family tradition, Florence David specializes in a range of fancy baskets that includes sewing baskets, strawberry baskets, and button baskets. Although she uses dyes for her strawberry baskets, she prefers the natural colors of the ash splints, which she combines with the fragrant smell of sweetgrass. For many years, she wove lacrosse sticks at Cornwall Island. Although recently retired, Florence continues to make her beautiful baskets while teaching her granddaughter, Dana David. She also does beadwork, quilting, and leatherwork, and sews ceremonial clothing, including ribbon dresses.

The late Angela Barnes (Passamaquoddy) left, with Jody Barnes, photo by Cedric N. Chatterley
Erin Barnes, left, with the late Theresa Gardner (Passamaquoddy), photo by Cedric N. Chatterley

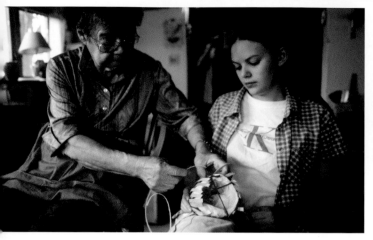 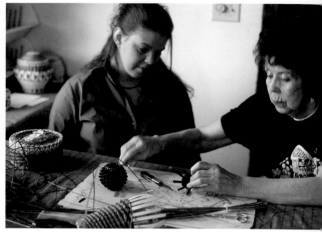

Elders are a primary source of culture and tradition in their communities. They are, as folklorist Barbara Kirshenblatt Gimblett suggests, "living links in the historical chain, eyewitnesses to history, and shapers of a vital and indigenous way of life." (Hufford, Hunt, Zeitlin, p. 74.) Having acquired this experience over a lifetime, they are masters of a certain kind of knowledge. Molly Neptune describes it this way: "The art of Passamaquoddy basket making has been woven throughout all aspects of my life. I have used it to teach myself, my children, my grandchildren, and others about Passamaquoddy traditions, history, and values. I have used basket making to teach discipline and patience. I realized from a very young age that I wanted to be a basketmaker. I not only wanted to learn, but I wanted to be able to pass on this beautiful art to my children, my grandchildren, and any others who wanted to learn."

A close relationship can develop between elders and the next generation interested in learning the tradition. It is the elder who has the time, experience, and need to pass on their knowledge, while a young person's interest can encourage the transference of skills from one generation to another. (Hufford, Hunt, Zeitlin, p. 86.)

But sometimes the beneficiary of this knowledge is not ready or interested in taking it up. Sometimes whole generations do not participate. These breaks in the chain are not irreparable, and in fact, they show the resilience of traditions. As Ralph Coe explains, "Disappearance of traditions did not take into account the innate ability of Indian traditions to withstand

Basket class at Akwesasne, photo courtesy of Salli Benedict

Basket class at Akwesasne, photo courtesy of Salli Benedict

erosion, and the extraordinary ability of Indian artistry to adjust to circumstance in remolding itself by assimilating technology and change." (Coe, p. 44.)

Through workshops and apprenticeships, the Akwesasne Museum and the Maine Indian Basketmakers Alliance have developed alternative ways to get the younger generation involved in traditional arts. These programs bring master artists together with apprentices for intensive instruction. More than lessons in technique, such pairings can also become personal and cultural relationships—what one observer calls "intimate conservatories." Such programs encourage the participation of all generations in the community, and help provide points of entry for young people while at the same time placing elders in positions of authority.

A strong bond forms when young and old begin to work together. Whether or not they belong to the same family, they begin to share a commitment to continuing the tradition. Theresa Secord notes, "The Apprenticeship Program has been a catalyst for many of us becoming basketmakers and continuing the work. I've been really amazed and proud at how some of our *elder* basketmakers, in particular, have made themselves available to teach. It takes a lot of patience and maybe they don't even want to share some of their skills and knowledge, but then they have forced themselves because they understand it must be that way. They must pass on their knowledge and their skills, even if it is to someone outside the family, because they understand how critical it is to make sure that a part of the culture is passed on to future generations."

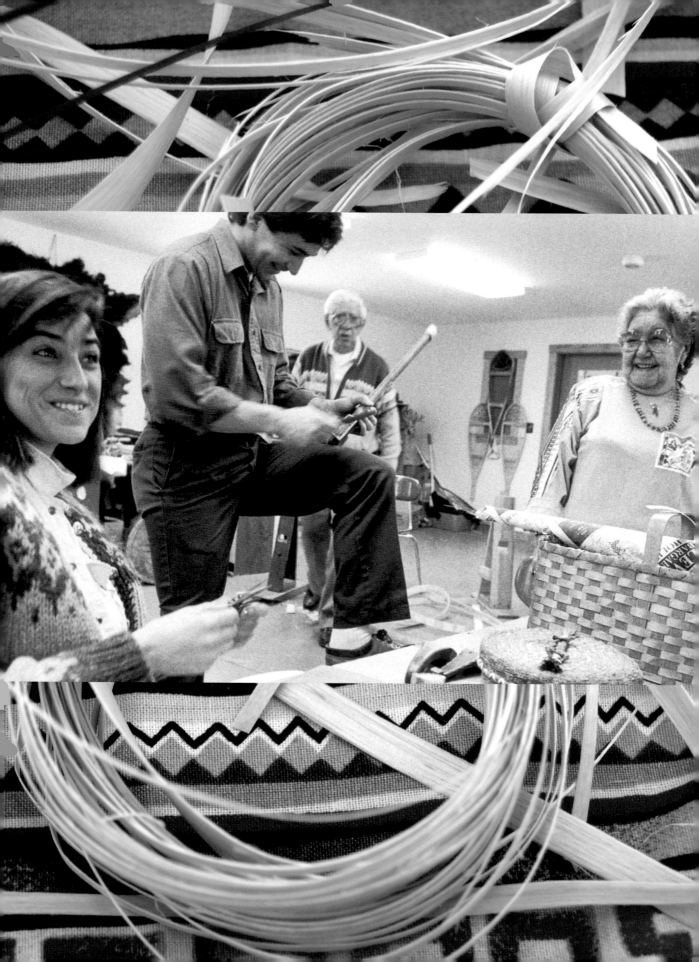

Theresa Secord, Penobscot

A passionate advocate for preserving the basketmaking tradition among the four Maine tribes, Theresa Secord is executive director of the Maine Indian Basketmakers Alliance, an intertribal organization dedicated to the preservation of the sweetgrass and brown ash basketry tradition. Once an apprentice of the renowned Penobscot basketmaker Madeline Shay, Theresa Secord has gone on to teach students of her own, including her niece, Shannon Secord.

Using the basket molds that she inherited from her great-grandmother, Philomene Nelson, Theresa Secord makes a variety of traditional Penobscot fancy baskets. "I always thought that I would make baskets and I think I thought that my great-grandmother would live forever," she says. "I was in college when she died and so I kept thinking that oh, I'll go up and work with her someday. She was ninety-one when she passed away. I don't know what I was waiting for. Luckily, I found someone who was very skilled and really a wonderful person, Madeline Shay."

Realizing Madeline Shay was one of the last Penobscot speakers and basketmakers, Theresa asked Madeline if she was willing to teach her Penobscot and basket making. For four years they worked together, until her death. Theresa was deeply touched by Madeline's passing, which brought home, more than ever, what her people were losing with each elder's passing.

"I didn't know it at the time," she says, "but when Madeline Shay taught me to make my first basket, she had selected me to be one of those entrusted with the Penobscot basket-making tradition. It wasn't until she passed on that a group of us realized the whole tradition would die if something wasn't done. It's a slow process to bring people back into this tradition. I think only time will tell. We

Opposite page: Theresa Secord, Barry Dana with the late Billy and Madeline Shay, photo by Cedric N. Chatterley

The late Sylvia Gabriel, left with Francis "Gal" Frey, photo by Cedric Chatterley

Doris Chapman with apprentice, photo by Cedric N. Chatterley

 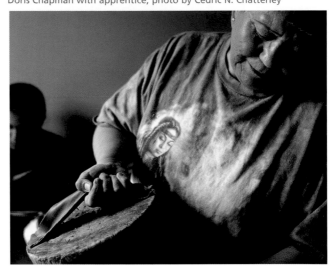

are a limited population so it means that those of us who are tribal members have to pick up the ball—pick up the basket—and go with it and make sure that those who want to learn are able to."

New generations of traditional artists enliven their community by reshaping old forms into contemporary life. As long as elders have younger people seeking out their expertise, the tradition will continue. This commitment requires mutual effort. As these basketmaking communities continue to evolve, they must invest in the next generation. As Caron Shay describes it, "Each generation that comes along behind the rest will learn."

The flow of knowledge from one generation to the next doesn't always move in one direction; there is a give and take. In the hands of the next generation who practice them, these traditions are transformed. Changes in lifestyle, in the work itself, can reflect new materials, methods, and styles, but the spirit remains. Created within a circle of history, reworking old forms to reflect a living, contemporary community is part of the tradition. How the tradition continues is the challenge of each new generation.

Pam Cunningham in studio making baskets, photo by Cedric N. Chatterley
Shannon Secord, left, with Theresa Secord, right, photo © Peter Dembski

"Basket making for me is about innovation and creativity within the context of a traditional art form. The functionality, the materials, and the shapes have been a legacy to each generation. I honor that legacy and believe I have a responsibility to continue it, basing it always on our traditions and knowledge of literally thousands of years. Basket making is an art that I believe I was born to do, much as my ancestors have for thousands of years." —Molly Neptune Parker

Adney, Edwin T., and Howard I. Chapelle. 1964. *The Bark Canoes and Skin Boats of North America*. Washington, D.C.: Smithsonian Institution.

Akwesasne Museum and Cultural Center. 1983, 1996. *Teionkwahontasen: Basketmakers of Akwesasne*. Hogansburg, New York.

American Friends Service Committee. 1989. *The Wabanakis of Maine and the Maritimes*. Philadelphia, Pennsylvania.

Benedict, Les, and Richard David. 2000. *Handbook for Black Ash Preservation, Reforestation/Regeneration*. Hogansburg, New York: Mohawk Council on Akwesasne, Department of Environment.

Benedict, Salli. 1983. *Sweetgrass Is Around Us: Basketmakers of Akwesasne*. Hogansburg, New York: Akwesasne Museum.

Bernstein, Bruce. 2003. *The Language of Native American Baskets: From the Weaver's View*. Washington: National Museum of the American Indian.

Coe, R. T. 1986. *Lost and Found Traditions: Native American Art 1965–1985*. New York: Federation Arts.

Eckstrom, Fannie H. 1932. *The Handicrafts of the Modern Indians of Maine*. Bar Harbor: Lafayette National Park Museum Bulletin 3.

Hill, Tom, and Richard W. Hill, Sr. 1994. *Creation's Journey: Native American Identity and Belief*. Washington: Smithsonian Institution Press.

Hufford, Mary, Marjorie Hunt, and Steven Zeitlin. 1987. *The Grand Generation: Memory, Mastery, Legacy*. Washington: Smithsonian Institution.

Kennedy, Kate. 2006. *Florence Nicholar Shay: Penobscot Basketmaker and Tribal Advocate*. Old Town, Maine: Charles Norman Shay.

Knapp, Millie. 1992. "Circle of Unity: Portraits and Voices of Seven Native American Women," *Turtle Quarterly*, Spring-Summer.

Konrad, Lee-Ann, with Christine Nicholas. 1987. *Artists of the Dawn: Christine Nicholas & Senabeh.* Orono, Maine: Northeast Folklore Society.

Lester, Joan. 1987. *We're Still Here: Art of Indian New England.* Boston: The Children's Museum, 1987.

Lyford, Carrie A. 1982. *Iroquois Crafts.* Stevens Point, Wisconsin: R. Schneider Publishers.

Maine Indian Basketmakers Alliance. 1996. *A Wabanaki Guide to Maine.* Old Town, Maine.

McBride, Bunny. 1990. *Our Lives in Our Hands: Micmac Indian Basketmakers.* Gardiner, Maine: Tilbury House, Publishers.

Mundell, Kathleen. 1992. *Basket Tree/Basketmakers.* Augusta, Maine: Maine Arts Commission.

Nicks, Trudy. 1999. "Indian Villages and Entertainments," *Unpacking Culture: Art and Commodity in Colonial and Postcolonial Worlds.* Edited by Ruth B. Phillips and Christopher B. Steiner. Berkeley: University of California Press.

Phillips, Ruth B. 1990. "Moccasins Into Slippers," *Unbroken Circles: Traditional Arts of Contemporary Woodland Peoples. Northeast Indian Quarterly*, Winter.

Sanipass, Mary. 1990. *Baskadegan: Basket Making Step-by-Step.* Madawaska, Maine: St. John Valley Publishing Company.

Speck, Frank. 1940. *Penobscot Man: The Life History of a Forest Tribe in Maine.* Philadelphia: University of Pennsylvania Press.

Thoreau, Henry David. 1981. *The Maine Woods.* New York: Crowell.